Sketching BIRDS

Pen, Pencil, & Ink Wash Techniques

FRANK J. LOHAN

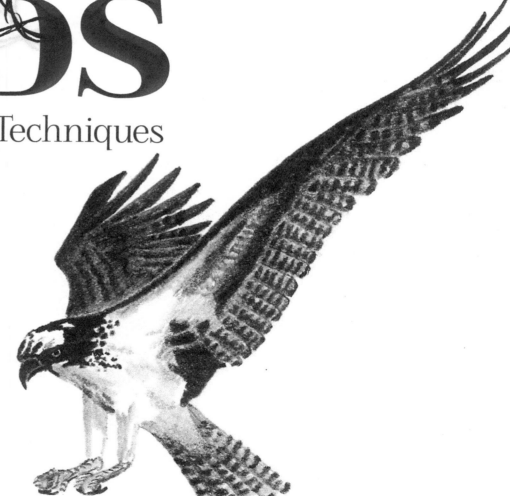

DOVER PUBLICATIONS, INC.
Mineola, New York

Bibliographical Note

This Dover edition, first published in 2012, is an unabridged republication of the work originally published by Contemporary Books, Inc., Chicago, in 1990.

Library of Congress Cataloging-in-Publication Data

Lohan, Frank.
 Sketching birds : pen, pencil, and ink wash techniques / Frank J. Lohan.
 p. cm. — (Dover art instruction)
 This Dover edition, first published in 2012, is an unabridged republication of the work originally published by Contemporary Books, Inc., Chicago, in 1990.
 Summary: "A renowned artist and expert instructor shows how to depict birds of all kinds, from a baby robin to a flying osprey. Accompanied by more than 350 easy-to-follow illustrations, the nearly 60 lessons begin with basic line drawings, advancing to the use of pen, pencil, and ink wash techniques to produce texture and movement in realistic sketches"— Provided by publisher.
 Includes bibliographical references and index.
 ISBN-13: 978-0-486-49076-2 (pbk.)
 ISBN-10: 0-486-49076-9
 1. Birds in art. 2. Drawing—Technique. I. Title.

NC782.L64 2012
743.6'8—dc23

2012019695

Manufactured in the United States by LSC Communications
49076902 2018
www.doverpublications.com

To B J . . . like this work, full of hope
and promise for the future

Contents

Introduction

This book is a bird-drawing primer. It is designed for anyone from teenagers to centenarians; novices, students, and artists accomplished in other media; anyone who is fascinated by the beauty of birds and has a desire to further enjoy their beauty by drawing them.

My intention is to *quickly* capture your fascination with and enthusiasm for drawing birds by showing you how easy it can be—actually, you will show yourself how easy it is by following the step-by-step instructions. This "recipe book" approach is aimed simply at fostering drawing practice on your part by making such practice immediately rewarding. Practice of something frustrating is soon abandoned, and because drawing birds can be a very pleasant hobby, it would be unfortunate if learning to draw them should prove discouraging early on. By doing the lessons in this book you will gain a dexterity with the tools and materials of drawing without having to spend forty years learning how to use them, as I did. You will also get a good idea of how to create textures that suggest the varied plumage of different birds. Once you find out that you *can* draw them, I hope that you will be hooked on drawing birds.

Enthusiastic interest is the key to going further on your own. Once you do most of the lessons, you will be equipped with a "tool kit" of techniques that you can then apply to your own subjects. Remember, learning to draw is a never-ending process that is furthered only by practice.

Certainly there is far more to the art of drawing than just techniques. The ability to "see" is essential, because all art is abstraction of specifics from a complex mass of structure and tonal relationships that the eye observes. The eye must see critically, and drawing develops critical observation. My earlier book *Wildlife Sketching* goes into the geometry of natural things, including birds, to make critical seeing a little easier by giving you a way to look at structure.

The selection of what to put in your drawing, and what is extraneous to what you want to portray, is your personal statement; and that is all an original work of art is, be it painting, drawing, sculpture, musical composition, or dance. Any drawing, or painting for that matter, that is copied without change from the creation of others is not original art; it is practice and is just as valuable to personal development as

the playing of classical compositions by aspiring musicians. But copies should never be portrayed as original art.

If you can already draw well, then create your own working drawings for the lessons in this book and use my step-by-step instructions as a guide to your creation of the plumage textures. If you cannot draw well, just copy or trace my working drawings and transfer them to your paper as instructed in Chapter 3. Then follow the step-by-step instructions to put the (sometimes complex) tones and features of plumage on your drawing. You will quickly gain reasonable proficiency with the pencil and pen, as well as the confidence that is essential to carry your practice further. And that is the objective of this book.

The early lessons deal with relatively simple subjects, but as you develop some proficiency with the tools and materials, you will find that the subjects become more complex. In the final lessons you will be drawing several subjects that have no accompanying step-by-step instructions. These are a sort of final exam for you to assess how much you have learned from the earlier lessons and how well you can apply what you have learned.

1
Tools and Materials

In order to follow the exercises in this book, you will need a few basic tools and materials. All can be obtained at any art supply store. In each of the lessons I list the necessary tools and also name the tool or tools that I used for each of the illustrations.

Essential Tools and Materials

You will need some wooden drawing pencils; a crowquill pen holder, pen points, and ink; erasers; some inexpensive drawing paper with a vellum, or slightly rough, finish; some tracing paper; a number 5 watercolor brush; and a tray to hold ink washes. These are the basics. For about six or seven dollars, you, as a casual student, can equip yourself for years of sketching with these simple tools and materials.

Optional Tools and Materials

As with any other hobby, you can upgrade to more expensive items that offer you, as a serious student, certain conveniences. Such upgrades include an artist's fountain pen or a technical drawing pen (each of which will cost about fifteen dollars); a mechanical pencil (about four dollars) to hold 0.5-millimeter (mm) HB leads; and seventy-pound vellum-finish drawing paper (three or four dollars a pad). You *can* draw very well without these items. If you draw quite frequently, however, their convenience is significant.

Reference Materials

There is one important thing for the beginning student to remember: you can't draw what you can't see and don't know! This is why all serious artists draw from life or from museum specimens. The next-best thing is photographic reference material—but a photograph masks as much as it presents and should be backed up with notes made on the spot or by notes from other source materials to provide necessary details. Audubon bird guides, Golden Book bird guides, Roger Tory Peterson bird guides, encyclopedia sections on birds, and good nature magazines are just a few of the sources you can use for reference when you want to do your own sketching. From these sources you can get good ideas for bird postures as well as coloration details. So do not be disappointed if you find you cannot simply sit down and draw a credible bird just from memory. Your memory, as well as mine, is faulty and will mislead you to some degree if

you do not know your subject very well from previous study and drawing practice. Having good reference materials is equally as important as having the necessary tools. Indeed, reference material *is* a necessary tool.

In this book I provide you with the necessary reference materials so that you can redraw, copy, or trace my working drawings provided with each lesson and get on with the techniques of texture representation that each lesson offers. Once mastered, these techniques will then serve you when you do your own original bird drawings.

Pens

Crowquill Pen

The old standby pen is the replaceable-nib crowquill. It is like the pen some of us used in our first days in school and is illustrated in figure 1-1.

You load it by dipping it into ink in a widemouthed container (a shot glass works very well) or by using the eyedropper that comes with the ink, illustrated in figure 1-5. Do not let the ink dry on the point while you draw because drying ink makes the flow of the ink quite erratic. I keep my point clean by wiping it with a paper towel and redipping. The crowquill will work with any dark ink, even the most heavily pigmented India inks. If the point happens to become clogged with dried ink, just soak it overnight in a mixture of one part ammonia and one part liquid soap, and then wipe it clean in the morning.

Points come in a variety of flexibilities. The more flexible ones allow a varying line width, depending on how much you push down as you draw. You should experiment with several different points—they are not very expensive.

Technical Drawing Pen

Most engineering drawing these days is done with a technical pen, shown in figure 1-2. This kind of pen is *not* flexible; each point makes just one line width. If you need a different width, you must use another pen—one that has a point with the desired width. Many artists have taken to these pens for fine-art drawing. My favorite is a 3×0 point (0.25 millimeter), and I used it for all technical-pen drawings done in this book. These pens sometimes have a removable plastic container to hold the ink; fill them as shown in figure 1-7.

You must use only ink that is made for technical pens, as some of the highly pigmented India inks can clog badly. Purchase the ink at the same place where you buy the pen.

Artist's Fountain Pen

Another favorite tool is the artist's fountain pen (fig. 1-3). It does away

Figure 1-1

Crowquill pen and typical points.

Figure 1-2

A typical technical drawing pen.

Figure 1-3

An artist's fountain pen.

with the constant loading of ink necessary with the crowquill and also provides a flexibility of line width that is often essential in drawing. This pen does not clog as easily as the fine-point technical pens but still needs an ink that is quite fluid. My only complaint with this type of pen is that even the so-called fine points are quite broad. I use crowquills or technical pens for the really fine-line work I do and the fountain pen for the bolder work.

Inks

A crowquill pen will work with any ink, even those that contain varnish or shellac to give them waterproof properties. Again, if the ink clogs, a simple overnight soaking in one part ammonia and one part liquid soap cleans it out. Inks come in a variety of bottles. India inks often come in bottles shaped like those in figure 1-4 and have a built-in eyedropper for use in loading the pen points, as in figure 1-5.

Alternatively, you can pour some of the ink from the bottle into a shot glass and dip the pen instead. When you are finished with a drawing session, you simply pour the unused ink back into the bottle.

Many technical pens have a removable plastic cup to hold the ink. Certain inks are made specifically for technical pens to minimize clogging, and the ink containers have spouts to fill these cups. These ink bottles frequently look like the one in figure 1-6 and are used to fill the cups, as shown in figure 1-7.

Some artist's fountain pens have a

built-in plunger for filling the ink reservoir. These pens require a widemouthed ink bottle into which you can immerse the point while you work the plunger by twisting or by pulling and pushing, depending on the make of pen.

Waterproof inks are preferred because moisture from your hand has a tendency to smudge a line drawn with nonwaterproof ink.

For the wash drawing lessons in this book, I used a waterproof India ink like that used for crowquill pens, diluted with ordinary tap water.

Figure 1-4

A typical India ink bottle.

Figure 1-5

Using the eyedropper to put ink on a crowquill point.

Figure 1-6

Typical technical pen ink bottle.

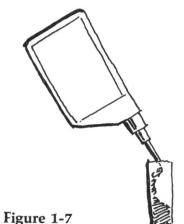

Figure 1-7

Filling the removable ink container of a technical pen.

Pencils

Only three wooden drawing pencils are required to do the lessons in this book: a 3B (or a 4B) and an HB, as you see in figure 1-8, and a 2H. The 3B and the 4B have very soft lead. The HB has a lead that is somewhat harder, but it's soft when compared with the 2H.

Sharpened as instructed, each of these pencils will make a light tone when gently touched to the paper and a very dark tone when pressed firmly to paper that has some "tooth" or roughness. Intermediate tones are obtained by varying the pressure on the pencil and by judicious use of the kneaded eraser, which is described later. Being able to achieve a wide range of tones is essential in drawing anything.

One nonessential, but very convenient, additional pencil I use is a mechanical pencil with very fine—0.5 millimeter—HB leads, illustrated in figure 1-9. Even though properly sharpened wooden lead pencils can produce the finest of lines, I sometimes like to use the mechanical pencil, which is always sharp because it has so narrow a lead.

Wooden drawing pencils are sharpened in two steps. First, expose about a quarter inch of the lead by carefully cutting away the wood with a sharp knife or razor blade. Second, put

Figure 1-8

Wooden drawing pencils.

Figure 1-9

A 0.5-millimeter lead mechanical pencil.

Figure 1-10

Using sandpaper to properly point up a wooden drawing pencil for broad-point sketching.

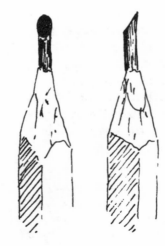

Figure 1-11

A properly sharpened broad-point drawing pencil.

a bevel on the lead by holding the pencil at an angle and rubbing it for a few strokes on fine sandpaper (fig. 1-10). This produces a broad point (which is used to tone larger areas through the use of the flat part produced by the sandpaper) and a sharp point (which is used for making fine lines). A properly sharpened broad-point is shown in a front view and a side view in figure 1-11.

Erasers

A kneaded eraser is essential for pencil drawing. While you can erase light pencil lines by rubbing it back and forth like an ordinary eraser, you can also press it without rubbing to a pencil drawing and lift away a little of the graphite. Each time it is pressed and lifted away, it slightly lightens the tone. After it has been used, you must knead the dirty part into the inside of the eraser so that the graphite lifted from the drawing doesn't leave a dirty mark on the paper the next time you go to lift off some more. This is a great way to gently create the exact tone you want in areas of a pencil drawing that turn out to be too dark or in areas where you need greater contrast because the subject is too close in tone to the surrounding objects. Those surrounding items can be lightened slightly by shaping the kneaded eraser in your fingers and pressing it to the paper. This can be done several times to achieve the precise tone you want.

You will also need an ordinary soft art-gum or Pink Pearl–type eraser to erase the pencil composition lines from your ink drawings after the ink dries.

Brushes and Washes

An alternative way to draw a subject is with a watercolor brush and a waterproof ink wash. A wash is a diluted pigment applied with a brush. In this book the pigment called for is India ink, and it is diluted with water. Using waterproof rather than nonwaterproof ink means fewer problems for a beginning student.

The wash is applied to the paper with a watercolor brush. When wet, a good watercolor brush forms a sharp point with which you can draw finely detailed lines. It also can be used to cover larger areas with wash. The kind of brush that comes with inexpensive watercolor kits for children is not at all suitable because it does not "point up" to a sharp point. All the wash demonstrations in this book were done with a number 5 watercolor brush, illustrated in figure 1-12.

Preparing the Washes

I use a small plastic tray with depressions, as you see in figure 1-13, to prepare washes of different densities. A reasonable range of tones to work with can be set up, with clear water at one end of the tray and straight India ink at the other. Five gradations of tone between these extremes can be prepared as follows: Put one teaspoon of water into each of four depressions in a wash tray and two teaspoons into a fifth depression. Then add one drop of India ink to the two teaspoons of water, one drop to the next depression, three drops to the third, eleven drops to the fourth, and seventeen drops to the fifth. Stir them all with a toothpick, and you are ready to go. The range achieved can be seen in the next chapter, "Sketching Techniques," figure 2-18C.

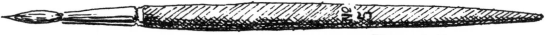

Figure 1-12

A number 5 watercolor brush.

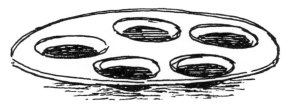

Figure 1-13

A typical tray with a wash of different density in each depression.

Using the Washes

There is one thing you should keep in mind when you use washes: each stroke is additive. This means that if you go over an area of dried wash with another stroke of the same wash, the area will become darker. It will be darker yet with a third stroke. This is illustrated in figure 1-14. When you want to

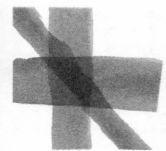

Figure 1-14

Each time you go over a dried wash it gets darker. Each of the three stripes carries the same density (tone) ink.

gradually darken a passage this is fine, but if you inadvertently go over an area that you do not want to darken, be sure to blot it immediately with a paper towel to correct the error.

Paper for Wash Drawing

Do not use ordinary typing paper or copier paper for wash drawings. The paper is too thin for so much fluid and will wrinkle and buckle. Heavier paper, such as seventy-pound or better yet 140-pound paper, will be far more satisfactory. All the little wash illustrations in this book were done on seventy-pound vellum-finish paper.

Papers

You will need several kinds of paper to properly do the lessons in this book.

Tracing Paper

Tracing paper is essential if you want to trace and then transfer your own composition drawings to the final paper after you get the proportions as you want them. If you do not draw well yet, you can trace my composition outline drawings for each lesson and transfer that to your final paper. If you follow the instructions for doing this in Chapter 3, Lesson 1: Tracing and Transferring an Outline, you will be able to prepare new working drawings quickly and start over on fresh pieces of paper should you become dissatisfied with the way your drawing is going at any point.

Vellum-Finish Paper

Vellum-finish paper is slightly rough. It has a "tooth" to it that lets the graphite from your pencil stick to it more easily. Plate-finish paper, which is smooth, is good for ink and wash; however, the vellum-finish works well for all the media used in these lessons. Unless otherwise mentioned, all drawings in this book were done on seventy-pound vellum-finish paper.

You can get pads of heavy universal drawing paper, good for pencil, pen, and watercolor, at any art supply store. Such paper will do quite well for the casual student. If you intend to draw often and seriously, you may want to try some of the more expensive, specialized papers such as two-ply kid-finish or vellum-finish bristol board, which are both excellent surfaces for pen-and-ink work, ink wash, and most pencil work.

Linen Paper

There are many textured papers, but the linen-finish paper gives a real charm to some pencil drawings. The embossed linen texture shows through broad-point passages as you can see in figure 1-15 and lends an additional interest to the study.

Figure 1-15

A broad-point pencil drawing of a great blue heron done on linen textured paper. You can see the linen texture in the dark passages.

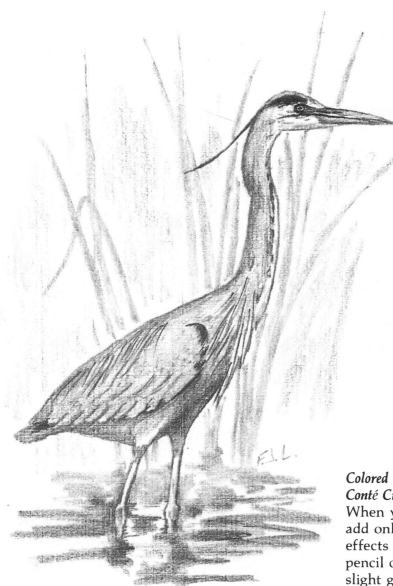

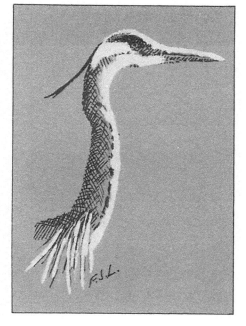

Figure 1-16

A pen-and-ink and white gouache
drawing done on brown paper. You can
also use a white Conté crayon for the
white areas.

Colored Paper and White Paint or White Conté Crayon

When you draw on white paper you can
add only darker areas to create the
effects you are after, whether you use
pencil or pen. If you use paper with a
slight gray or brown tone, however, you
can put darker areas on it and, with
white watercolor, white gouache (an
opaque water-based paint), or white
Conté crayon, you can go in the
opposite direction as well, creating
lighter areas as you see in figure 1-16.
The gouache can be applied with the
same watercolor brush that you use for
the wash lessons. Just be certain to
clean it well with soapy water each time
you use it for either gouache or ink.

2
Sketching Techniques

Pen and ink, pencil, and ink wash each have particular techniques that are generally employed in their use. Learning about them does not mean that innovation and experimentation are discouraged; it simply means that if you are a beginner, you will be able to progress more quickly to the knowledgeable experimentation stage if you know the fundamentals first, rather than learning them as you go along on your own.

A drawing is nothing more than a group of visual impressions that evoke recognition from a viewer. All you have to create your visual impressions are various gray tones, or values, between the white of the paper and the blackest black you can produce. Sketching techniques are the ways that you create the varying tones with each of the media.

Pen-and-Ink Drawing

Hatching is one of the primary ways to create gray tones with pen and ink. It is nothing more than drawing a series of closely spaced parallel lines in order to partially cover an area of white paper with black ink. Hatching to create a uniform gray tone is illustrated in figures 2-1 and 2-2. Hatching to create a graded tone, one that changes gradually from dark to light (or light to dark), is shown in figure 2-3. When the lines are spaced farther apart, the tone produced is lighter than when the lines are very close together.

It is very important that you be able

Figure 2-1

Typical pen-and-ink hatching.

Figure 2-2

Uniform hatching.

Figure 2-3

Graded hatching, created by widening the spacing between the lines to get a lighter gray.

Figure 2-4

Poor hatching techniques:
(A) Groups overlap.
(B) Space between groups.

Figure 2-5

Poor hatching technique:
irregular spacing of lines
and groups of lines.

Figure 2-6

Crosshatching to achieve
dark tones: One layer of
hatching (A) with a
second layer added on
top (B), then a third
layer (C), and finally
a fourth (D).

to hatch with relatively *uniform* lines and that the groups of such lines tuck closely together without overlapping and without leaving little white spaces between them. Each of these improper ways of hatching is shown in figure 2-4.

When your hatched lines are not done uniformly, as in figure 2-5, the results are extremely unsatisfactory. Knowing how to produce the gray tones you need in different areas of your drawing is an essential skill and one that will come only with practice. Practice hatching areas about the size shown in these illustrations until you can do it uniformly. Believe me, it will make getting pleasing effects with the pen much easier as you proceed with the lessons in the rest of the book.

Crosshatching is simply hatching over a previously hatched area but with lines in a different direction. This covers more of the white paper with ink and thereby produces a darker tone. Hatching a third time over such an area produces a still darker passage. I have found that when my hatch lines are quite close together, I seldom have to use more than four layers to get an area as dark as I need. Crosshatching is shown in figure 2-6.

Avoid outlining everything with lines. If overdone, as in figure 2-7, outlines can make your drawings look like they came from a child's coloring book. The same subject, drawn with no ink outlines at all, is shown in figure 2-8.

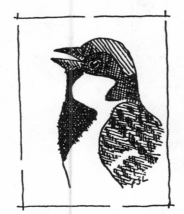

Figure 2-7

Too much outlining spoils
the effect of a sketch.

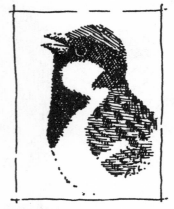

Figure 2-8

Often no outlines at
all are required.

12

When you hatch and crosshatch areas that are adjacent to lighter or darker areas, you seldom need to use outlines to separate these visual elements; the toned areas do the separating, as you can see in figure 2-8. Naturally, I use pencil outlines to guide my inking, but as soon as I no longer need them I erase these lines to avoid smearing the graphite all over my drawing as I work.

Stipple drawings consist only of dots—there are no lines at all. To create dark areas you put more dots on the paper to cover more of the white. The stipple drawing shown in figure 2-9 was done with a fairly coarse pen; a finer pen point will produce a less grainy appearance. Stipple drawings take longer to do than those that have lines, hatching, and crosshatching, because you put such a little bit of ink on the paper with each dot. The effect is quite interesting, however, and is often worth the time it takes to do.

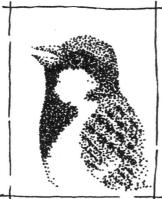

Figure 2-9

An ink stipple (just dots of ink) version of the English sparrow.

Pencil Drawing

You should have three pencils, a 2H, an HB, and a 3B or a 4B, sharpened as shown in Chapter 1, figures 1-10 and 1-11. I also recommend a 0.5-millimeter mechanical lead pencil with HB leads for sharpening small details and the edges of toned areas. The broad-point pencils are used to lay down broader toned areas. Each of the recommended leads makes tones as you see in figure 2-10 when used on vellum-finish paper. The smoother the paper, the lighter the tones will be. The pencil needs paper with a "tooth" to hold the graphite and thereby produce darker lines and areas.

With the broad-point pencils, you draw wide lines next to each other to produce toned areas. At first you may find that you get a result as shown at A in figure 2-11 in which each of the separate strokes is visible. With a little practice, however, you will be able to touch the point to the paper uniformly and get results more like those shown at B in figure 2-11.

When you tone an area with the broad-point pencil, the edge of that area is not very distinct or sharp. If you leave it that way, your drawing will look fuzzy and your subject may not appear to be well separated from the background. Figure 2-12 illustrates how a toned area is sharpened. First you tone

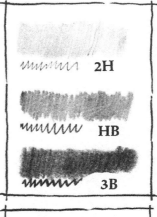

Figure 2-10

Typical pencil tone created by hard (2H), medium (HB), and soft (3B) leads.

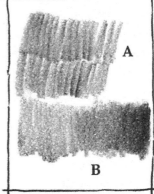

Figure 2-11

Toning with broad-point pencils. (A) Lack of control. (B) Good control.

Figure 2-12

(A) A toned area made with a broad-point pencil. (B) The edge sharpened by a sharp HB pencil. (C) The edge line toned out so it is not apparent.

the area; second, you make the edge of that area sharp with a sharp point—but don't make the line *too* dark. Finally, you gently build up the tone alongside the line so that the line itself is no longer apparent but the toned area is very sharply defined. This approach is demonstrated in figures 2-13, 2-14, and 2-15 (pencil drawings of an English sparrow).

Drawing an English sparrow with the pencil is a good way to practice what I have just described. Start by copying or tracing the outline of the subject from figure 2-19. Then, referring to figure 2-13, use the 3B broad-point pencil for the darkest areas and the broad-point HB for the lighter head and cheek areas. *Remember to make your working pencil drawing as light as possible, because you can't erase these guidelines as you can with an ink drawing.*

You can see in figure 2-13 that the edges of the bird are not at all distinct. I used my mechanical pencil with HB lead to sharpen up the edges and complete the eye and beak to get figure 2-14.

A dark background can sometimes be interesting. When you do use one, remember to make the background a different tone from that of your subject, or you will lose the subject. In the case of figure 2-15, I made the background darker where my subject is lighter, and lighter where my subject is darker to avoid losing parts of the bird into the background.

14

Figure 2-13

The darker tones blocked in with broad-point pencils.

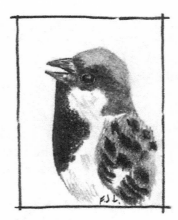

Figure 2-14

Sharpen the edges of the toned areas and add the details with sharp points.

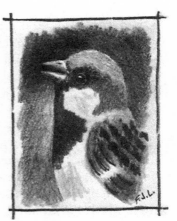

Figure 2-15

A dark background, or negative space.

Kneaded Eraser

It is difficult to create the precisely desired tone with each stroke of the pencil. For instance, on the bird's head in figures 2-14 and 2-15 there are two different tones; the cap is markedly lighter than the cheek area. When I first used my HB pencil to do both of these areas, they turned out to be too close in tone. I pressed a kneaded eraser on the crown area, and it lightened as you see. The kneaded eraser is a vital tool in adjusting your tones in pencil drawing. Its effect on the harder and the softer pencils is shown in figure 2-16. *Do not rub the kneaded eraser back and forth on the drawing. Just press it where you want to lighten a passage and then knead the dirty part into the inside of

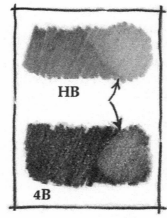

Figure 2-16

The lightening effect of pressing a kneaded eraser to an HB and a 4B toned area.

the eraser so you will not transfer the graphite to the paper the next time you use the eraser. You can shape the eraser with your fingers to adjust it to small or odd-shaped areas.

Ink Wash Techniques

Figure 2-17 shows an ink wash drawing of the English sparrow. The range of wash tones I used is shown in figure 2-18C. These were made following the recipe in Chapter 1. The setup and necessary tools for wash drawing are also discussed in Chapter 1. The lighter tones are usually built up by several applications of a light wash because you cannot remove a wash made from waterproof India ink once it has dried. The darker tones are created by using a darker wash. Wash drawings start with a light pencil working drawing, just as pen-and-ink or pencil drawings do.

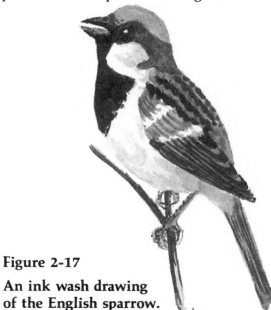

Figure 2-17

An ink wash drawing of the English sparrow.

A

B

C

Figure 2-18

A range of tones from white to black: (A) Pen and ink. (B) Pencil. (C) Ink wash.

Achieving the Tonal Range

The tonal range, in seven steps, from white paper to the darkest dark that I used in these demonstrations, is shown in figure 2-18. Open the book to this page, prop it up on a chair, and look at it from across the room. You will see how these three methods of making the different tones are pretty much equivalent. Until you back off some distance, all you see in figure 2-18A are ink lines. You see the gray effect only when you look at it from a distance.

It will work to your benefit to practice duplicating figure 2-18 a few times before you go on to the lessons that follow.

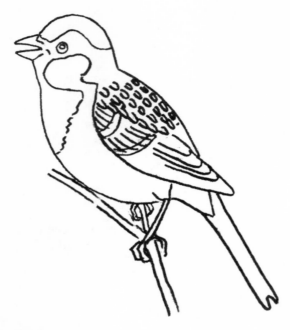

Working Drawings

Use figure 2-19 to create your own working drawings to try some of the things that I covered in this chapter. After copying or tracing the image, follow the instructions in the section in Chapter 3 called Tracing and Transferring an Outline to prepare some working drawings you can easily practice on.

Figure 2-19

Copy or trace this working drawing to try some of the techniques discussed in this chapter.

3
Lonesome, a Baby Robin

LESSON 1
Tracing and Transferring an Outline

Materials
Sharp HB pencil, broad-point HB or 3B pencil; tracing paper.

Procedure
This lesson shows you how to start each of the subsequent lessons in this book.

Before you start any drawing you should have a lightly drawn outline of the subject on your working paper, with the major details indicated. This outline will guide your pen or pencil as you complete the drawing, allowing you to concentrate on obtaining the proper texture without worrying about proportion and perspective at the same

time. The beginning artist does not need too many things to concentrate on simultaneously.

This procedure of preparing a traced image will be useful to you in doing each of the lessons in this book. Once it is prepared, you can use the tracing-paper image to make quite a few working drawings quickly in case you want to try different approaches or you are dissatisfied with your first attempts and want to start the sketch over again.

Follow the steps in figures 3-1 to 3-4 to make your transfer image. Place a piece of tracing paper over the subject (fig. 3-1). The subject can be a

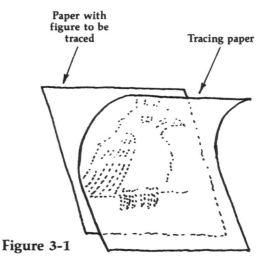

Figure 3-1

Place tracing paper over the image to be traced.

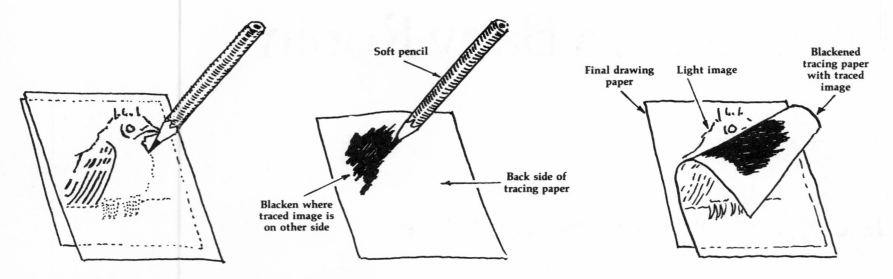

Figure 3-2

Trace the image using an HB pencil.

Figure 3-3

Turn over the tracing paper and blacken the area behind the drawing with a soft pencil.

Figure 3-4

Place the blackened side down on your final paper and draw over the traced image. A light copy of the image will be transferred to your final drawing paper.

composition drawing you made on another piece of paper, a photograph, a magazine illustration, or one of the working drawings I have included with each of the lessons in this book. Next, draw the outline and essential details (fig. 3-2). Then turn the tracing paper over and put graphite from a soft pencil

(such as an HB or 3B) on the back to cover the image area, as in figure 3-3. This graphite acts as carbon paper and allows you to transfer a light image to your final drawing paper by simply drawing over the image on the tracing paper when it is placed on your final paper, as in figure 3-4. You can do this

a number of times before the back must be blackened again.

Unless you prefer to make your own original working sketch for each exercise (and this is the best way to go if you can draw well), this procedure should be followed for each of the lessons in this book.

18

LESSON 2
Pencil Approach to Lonesome

Materials

Sharp HB lead pencil, broad-point HB lead pencil; seventy-pound vellum-finish paper.

Procedure

This subject is shown completed in figure 3-5. Use this illustration as a guide as you follow the instructions to make your own drawing.

The first step is to prepare a light pencil outline on your final paper. Since you are using pencil, I recommend a vellum-finish paper because it is a little rougher than a plate finish and will take the pencil a little better. Prepare your tracing transfer figure of the bird as described in Lesson 1. You can trace figure 3-6 in preparing your tracing-paper transfer image if you like. When you have made your transfer, your final paper should look something like figure 3-6.

Figure 3-7 shows each of the steps you now take to complete the drawing. First, as in step 1, draw the eye, using the sharp HB pencil. Be sure to leave a little highlight near the top of the eye to give it some glisten. Next, using the

broad-point HB, mark the wing feathers as you see at A in step 2. Do not run these together—you want some white space to define each feather. Then emphasize the right-hand edge of each feather with the sharp HB, referring to A and B in step 3. The final work on the wing consists of going over all of the wing area with the broad-point HB, as was done at A in step 4. If the individual feathers tend to become lost, emphasize them further with the sharp point.

If you are dissatisfied with your drawing at this point, set it aside and prepare another working outline by tracing over the tracing paper image on another sheet of working paper. This takes only a minute or two, and you can then try the above steps again.

Do the head next, referring to figure 3-7, steps 5 and 6. In step 5 draw the dark features as you see at A; in step 6 use the broad-point pencil to tone the whole head a little, as at A. Then use the sharp point to emphasize the head feathers and the down that still clings to them, as at B.

The beak requires just a touch of tone

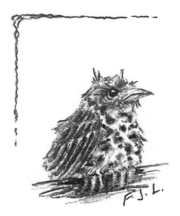

Figure 3-5

A pencil drawing of a lonesome baby robin out of the nest for the first time. This is the guide for your drawing.

Figure 3-6

This outline is to be traced and transferred to your drawing paper as shown in figures 3-1 through 3-4.

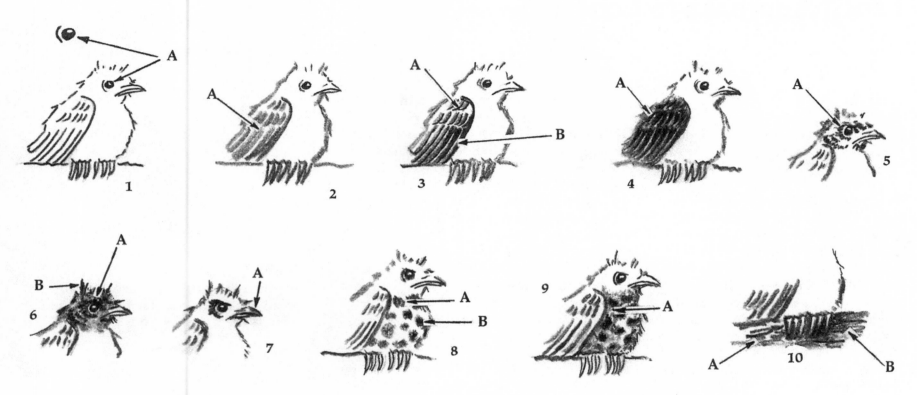

from the broad-point HB lead, as shown in step 7. The robin's breast is done with a broad-point HB to make the big smudges of graphite, as in step 8 at A; and then a little of the sharp point goes in the center (step 8 at B). You complete the breast with the broad-point HB by adding some tone to the edge of the breast and just to the right of the wings. This is shown at A in step 9. Leave a little white paper showing in the center of the breast.

The final step involves completing the bark on the branch, without losing the robin's toes (step 10). A little careful work with both broad-point and sharp HB pencils does the job. This is a quick exercise, so if you are not satisfied with your results, just prepare another working drawing from the tracing paper and try it again. You'll be surprised how much easier it is the second time.

Figure 3-7

This is the step-by-step process for completing a pencil drawing of the lonesome baby robin. See the text for instructions and hints on how to complete your drawing.

20

LESSON 3
Pen-and-Ink Approach to Lonesome

Materials

Fine-point pen; waterproof black India or drawing ink; smooth or slightly rough drawing paper. I used a 3×0 technical pen on seventy-pound vellum-finish paper. If you use a coarser pen point for this lesson, your line work will not match that shown in figure 3-8. A wider pen point does not produce "wrong" results, just different results.

Procedure

The completed pen sketch of the baby robin is shown in figure 3-8. Use it as a guide as you follow the step-by-step instructions in figure 3-9.

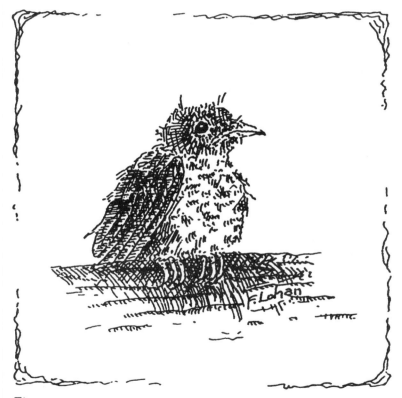

Figure 3-8

A 3×0 technical pen was used for this pen-and-ink drawing of the baby robin. The drawing includes outline, hatching, and crosshatching.

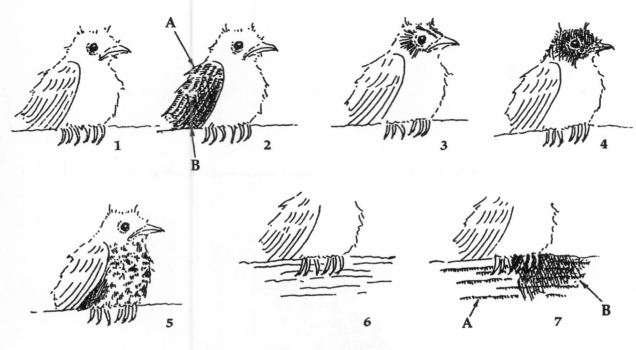

Figure 3-9

This is the step-by-step process to complete a pen-and-ink drawing of the baby robin. See the text for instructions and hints on how to complete your drawing.

The first step, as usual, is to prepare your light outline on the working paper. Use the tracing paper transfer image from Lesson 1, or draw the outline lightly in pencil on your working paper. Then ink it as you see in figure 3-9, step 1. When the ink is dry, erase the pencil marks so they will not smudge your drawing as you proceed.

The wing is textured in two steps. First, as you see at A in step 2, draw groups of hatch marks, with white paper showing between them, to suggest the individual feathers on the shoulders and wing. Second, hatch and crosshatch over the entire wing, as you see at B in step 2. Remember, you can start this very simple lesson over again quite easily and quickly at any time by making another light outline from your blackened tracing paper on another piece of paper.

You finish the robin's head in two steps also, as shown in steps 3 and 4. First, hatch the darker features as in step 3. Then crosshatch over the entire head area as in step 4. Be sure to leave a little white-paper ring around the bird's eye so that it does not lose its distinction and blend into the rest of the tone.

The bird's breast is finished in step 5 with patches of hatch marks (three or four little lines in each patch) and a little crosshatching to form some shade under the wing at the lower left part of the breast.

The final steps involve completing the texture of the wood on which the robin is sitting. This is shown in steps 6 and 7. First, draw some horizontal lines to suggest bark, and then put very short hatch marks under each line as shown at A in step 7, and crosshatch over the bark as at B.

LESSON 4
Other Pen Approaches

Materials

Medium-point pen or artist's fountain pen; smooth or slightly rough paper. I used my artist's fountain pen for these drawings (the point is not really very fine) and seventy-pound vellum-finish paper.

Procedure

Remember, every lesson in this book starts with a light pencil outline. If the drawing is being completed with pen and ink, you erase the pencil lines as soon as the ink is dry to minimize smudging of your drawing.

Figure 3-10 illustrates the stipple approach to pen work—just using dots of ink, with no lines at all. As you do a stipple drawing you may notice that some features start to disappear when you put the tone dots over them. If this happens, just go over the features again as you complete the overall toning. This will bring them out more prominently.

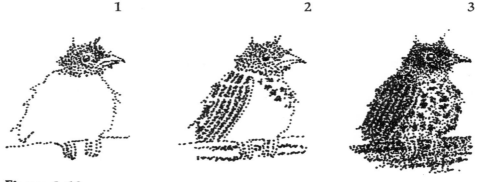

1 2 3

Figure 3-10

Pen-and-ink stipple.
(1) Dot the outline, and then start dotting the interior tones. (2) Dot the darker features. (3) Build up the tones, going over the darker ones when they become indistinct. *Use no lines . . . just dots!*

23

1　　　**2**　　　**3**

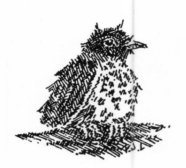

Figure 3-11

No outline.
This approach uses hatching and crosshatching only, with no lines except for the beak outline.

Figure 3-12

A stylized approach.
(1) Fully outline each dark feature. (2) Hatch the dark features. (3) Hatch the medium tones in a different direction, going right over the dark features.

Figure 3-11 shows the effect achieved with hatching and crosshatching only. No lines are used at all except for the robin's beak.

A stylized approach is shown in figure 3-12 in which an outline was used around every dark feature, with hatching inside the outlined areas. Follow steps 1 through 3 to try this rendition of the baby robin.

LESSON 5
Ink Wash Approach to Lonesome

Materials

Number 5 watercolor brush (one that forms a sharp point); watercolor paper (at least seventy-pound paper or, better yet, 140-pound watercolor paper with a finish that is not extremely rough); waterproof India ink, several little jars or plastic containers for mixing small quantities of washes. I used seventy-pound vellum-finish paper.

Note: in this lesson, always let the wash dry before placing another wash over it, unless stated otherwise in the instructions.

Procedure

Figure 3-13 shows what a number 5 watercolor brush looks like. It must form a sharp point when wet to allow you to draw the fine lines and details.

When you load this brush with an ink-and-water mixture, it makes a mark like that shown in figure 3-14 at the left. When you continue making strokes without reloading the brush, you approach a dry-brush stroke, as you see going to the right in figure 3-14. Such

Figure 3-13

A number 5 watercolor brush.

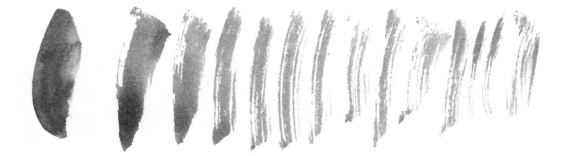

Figure 3-14

A range of strokes from the brush, from wet to dry-brush.

25

dry-brush strokes are very useful to render feather or bark textures. When you want such strokes but have just loaded your brush, make a few strokes on a piece of scratch paper before you make a stroke on your drawing. This will remove the excess fluid from the brush.

Each time you paint over a dried area with the ink-and-water mixture, the result will be darker, as you can see in figure 3-15. This is useful in slowly building up darker areas on your drawing.

Figure 3-16 shows the steps involved in drawing the wing of a bird with ink wash. First, as in step 1, suggest the individual feathers with a medium tone. Then, as in step 2, wash over the whole wing with a light tone after the first wash has dried. Finally, as in step 3, touch up the feather indications with a darker tone, using just the very tip of the brush to make sharp lines.

The completed ink wash drawing in figure 3-17 should be used as a reference for your drawing. The wing is drawn as described in figure 3-16 and shown step-by-step in figure 3-19, steps 1 to 3. First, draw the feather suggestions (step 1) then the overall lighter wash (step 2), and finally, do an additional definition of the feathers (step 3).

The robin's head is completed, as you see in steps 4 through 7, by first

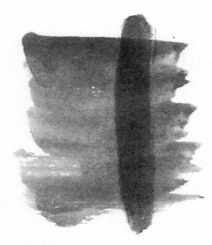

Figure 3-15

Each time you go over a dry patch of wash it becomes darker.

1 2 3

Figure 3-16

Typical steps in indicating a bird's wing feathers with waterproof India ink wash.

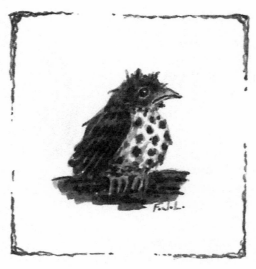

Figure 3-17

A quick ink wash study of the lonesome baby robin.

26

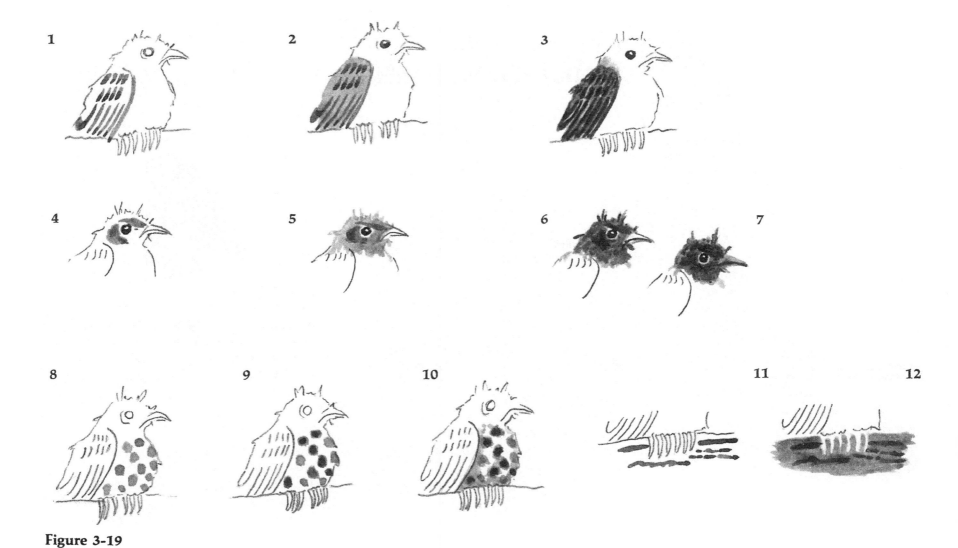

Figure 3-19

The step-by-step process to complete the baby robin drawing using waterproof India ink wash. See the text for instructions and hints on how to complete your drawing.

27

drawing the eye and the darker features of the head (step 4), and then applying an overall lighter tone wash (step 5). Next, the down still adhering to the head feathers is emphasized with darker tone and a sharp point (step 6), and a very light tone is applied to the beak (step 7). Be sure to leave a narrow, light ring around the bird's eye, or it will become indistinct.

The robin's breast spots are done as in steps 8 through 10. First, place light spots of tone on the breast (step 8); then, while they are still wet, touch a darker tone to the center of some of the spots (step 9). This is also shown in figure 3-18. The last step in completing the bird is putting some light tone on the lower left part of the breast and along the right side of the breast to indicate shadow (step 10).

Finally, do the bark in two steps: create lines of dark tone, as in step 11, and then an overall medium tone, as in step 12. Be careful not to obliterate the bird's toes when you do this.

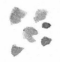 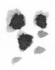

Figure 3-18

A wet-on-wet effect is achieved by touching some darker pigment to the center of the light breast spots while they are still very wet.

28

LESSON 6
Other Considerations

Materials
Artist's fountain pen or stick pen with replaceable nib; sharp HB pencil; copier paper or other smooth scratch paper, seventy-pound vellum-finish or plate-finish paper.

"Loose" Drawing
The pen allows good control of the drawing and permits the rendition of very fine details. Using this relatively uncontrolled technique as a relaxing exercise, try holding your pen at the top end, just with your thumb and forefinger, and draw the subject. My result can be seen in figure 3-20. This kind of loose drawing results because you cannot control the pen when you hold it in this manner—you can only guide it. Often a loose approach creates an appealing result because of the freedom that is obvious in the drawing. In making this drawing I used a light pencil outline and, just as with the previous examples, erased the outline when the ink was dry.

Figure 3-20

A "loose" sketch of the baby robin. I held the end of the pen with just my thumb and forefinger, which allowed very little control of the pen.

Altering the Pose
The basic geometry of this subject consists of two circles, a small one for the head and a large one for the body (fig. 3-21A). It is easy to change the pose somewhat by placing the beak in different places, as shown in figure 3-21B. I used these three different beak positions to complete the three studies shown in figure 3-22. Try making some simple changes and do your own variations on the basic pose used in the lessons in Chapter 3.

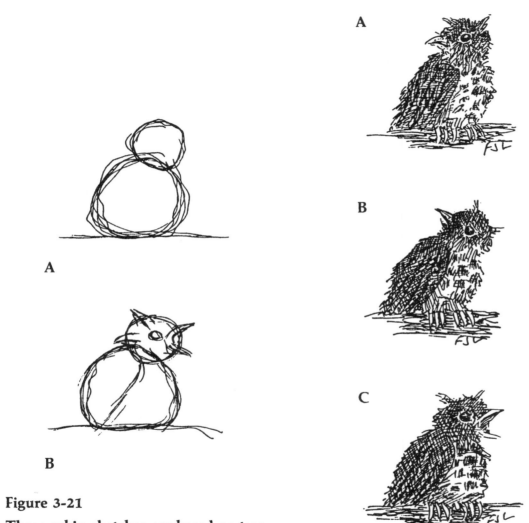

A

B

A

B

C

Figure 3-21

These robin sketches are based on two circles, a small one for the head and a larger one for the body. By putting the beak in different places, the posture can be changed.

Figure 3-22

Three different poses created by simply moving the bird's beak.

4
Hungry, a Subject with Some Action

The next series of lessons also deals with a baby robin. But this time we will make the drawing less static than the earlier study of Lonesome. Whenever possible, you should try to draw your subjects in poses that depict some kind of action that is natural to the bird. This makes the drawing more interesting than a simple static pose or a straightforward profile.

To get an interesting pose, a photograph of a bird shaped similarly to the one you want to draw can be used to make your working drawing. Details on the size of the tail and the coloration of your subject can be obtained from other photographs, and your working drawing can be adjusted accordingly. Proceeding this way, at least the placement of the head relative to the body and the way the wings are positioned will be reasonably accurate, even though you use a different bird for a model. Making such adjustments to a basic pose to draw different birds is covered in some detail in my earlier book *Wildlife Sketching*, on pages 48 and 49.

Figure 4-1

Working drawing for Hungry, a baby robin.

The working drawing for the next series of lessons is shown in figure 4-1. Copy this figure or trace it on tracing paper if you do not trust your drawing capability at this time. Then follow the instructions given in Chapter 3, Lesson 1: Tracing and Transferring an Outline, to prepare your working drawings.

It takes only a few minutes to trace another working drawing, so if at any time you become dissatisfied with the way your drawing is turning out, you can quickly prepare another working drawing and start over.

The first lesson in this chapter involves the pencil. I always rest my drawing hand on a separate sheet of paper when I draw in pencil. This prevents the side of my hand from smearing the graphite all over the paper as I work on it. A few smudges are inevitable and are easily cleaned up with the help of the Pink Pearl and the kneaded erasers, but a really smeared drawing is almost impossible to clean up completely.

LESSON 7
Pencil Drawing of Hungry

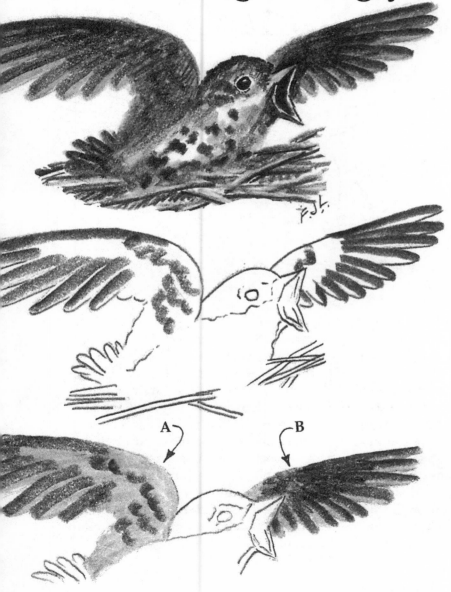

Figure 4-2

The completed pencil drawing of Hungry. Use it as a guide as you complete your drawing.

Figure 4-3

Use a broad-point 3B pencil to start the wings.

Figure 4-4

(A) Use a broad-point HB pencil to tone over the whole wing area. (B) Scrumble over the wings with a broad-point 3B pencil to get a feathery appearance.

Materials
HB and 3B or 4B broad-point pencils, sharp HB pencil; seventy-pound vellum-finish paper; kneaded eraser.

Procedure
Figure 4-2 shows my completed pencil drawing. Use it as a guide as you follow the step-by-step instructions for the drawing.

The first step is shown in figure 4-3. Use your broad-point 3B or 4B pencil to place a broad line along roughly half of each primary feather on the bird's wings. Then indicate some of the wing coverts with the same pencil by making some little half circles toward the shoulders.

Next, take your broad-point HB pencil and tone in the white areas of both wings so that they look like figure 4-4 at A. Then scrumble (rub in a somewhat haphazard way to get an irregular rather than a smooth tone) over the lighter and the darker areas with the broad-point 3B or 4B. Try to get a feathery appearance and to hide the individual dark strokes where they converge toward the bird's body. This is

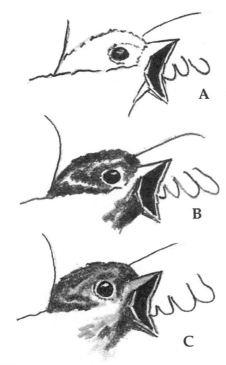

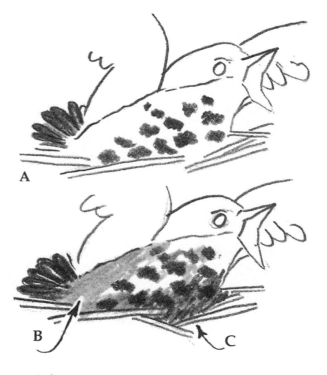

Figure 4-5

(A) A sharp HB pencil does the eyes and beak. (B) Use a broad-point 3B pencil for the darks on the head and throat. (C) Tone over everything with a broad-point HB pencil.

Figure 4-6

(A) A broad-point 3B is used to make the spots and the tail feathers. (B) Tone over with a broad-point HB pencil. (C) Use a broad-point 3B to scrumble a bit to get a feathery appearance.

shown at B in figure 4-4. Compare figure 4-4 with 4-2 to see what I mean.

Use your sharp HB pencil to detail the bird's eye and beak (fig. 4-5A). Then with your 3B or 4B broad-point, add the darker markings around the bird's head, eye, and throat (fig. 4-5B). Be sure to leave some white patches showing—you don't want to make the whole head a uniform, dark tone. Finally, finish the head, as shown in figure 4-5C, by toning over the head, beak, and upper throat with your broad-point HB.

Figure 4-6 shows you how to complete the breast and tail. A broad-point 3B or 4B marks the tail feathers and the dark breast spots, as shown in figure 4-6A. Then your broad-point HB tones some of the white paper (fig. 4-6 at B). *Do not tone the entire breast. You want a little white paper to show as a highlight, as you see in figure 4-2.* Finally, complete the breast by scrumbling over some of the HB tone with the softer broad-point, as shown at C in figure 4-6. Again refer to figure 4-2 to see the desired result.

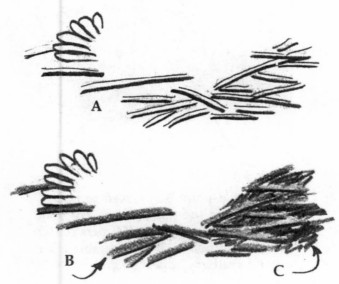

Figure 4-7

(A) Use a broad-point 3B pencil to underline just the bottom of each twig. (B) Lightly mark each twig with the broad-point 3B pencil. (C) Scrumble the white spaces between the twigs.

The last step in completing the drawing is adding the nest material. Here we just want to suggest all the little twigs and fibers that make up the nest by drawing a few and suggesting the rest with a coarse treatment of the white spaces between the ones we do draw. Figure 4-7 shows the three steps involved. First, draw a line along the bottom of each twig with the 3B or 4B broad-point (fig. 4-7A). Then, rather lightly, tone the rest of each twig as at B with the same pencil. Finally, use the edge of the same point to coarsely mark in the white spaces between the twigs as at C. You will probably find, as I did when I drew this lesson, that the twigs pretty much blended into the whole nest area at this point. I simply pinched my kneaded eraser so that it had an edge and pressed that edge on each twig to lift off a little of the graphite. That made each twig stand out, as you see in figures 4-2 and 4-7 at C.

LESSON 8
Pen-and-Ink Drawing of Hungry

Materials

Fine-point pen; smooth or vellum-finish (slightly rough) seventy-pound paper. I used a size 0 technical pen and smooth seventy-pound paper.

Procedure

Draw figure 4-1 on your working paper or trace and transfer it by following the instructions in Chapter 3, Lesson 1: Tracing and Transferring an Outline.

Figure 4-8 is the completed ink drawing of the baby robin. Use this figure as a reference as you complete your drawing, following the step-by-step instructions.

The first step is shown at A in figure 4-9. Hatch the upper half of each of the primary wing feathers. Next, crosshatch right over these marks and cover the entire wing area (fig. 4-9 at B). The darker areas are created by crosshatching again (fig. 4-9 at C).

Figure 4-8

Use this completed pen-and-ink drawing as a guide to complete your drawing.

Figure 4-9

(A) Hatch the upper half of each primary feather. (B) Crosshatch the entire wing area. (C) Add shading by crosshatching.

Figure 4-11

(A) Hatch the dark markings and the inside of the beak. Crosshatch the eye.
(B) Crosshatch to complete the head.
(C) Two short lines finish the beak.

Figure 4-10

(A) Hatch each tail feather.
(B) Crosshatch each feather.

Complete the tail on your drawing as was done in figure 4-10. First, hatch over each tail feather (fig. 4-10A), and then crosshatch each one (fig. 4-10B).

The head and beak are next. Put in the dark markings with hatching, as shown at A in figure 4-11, and then crosshatch over all the head and throat area, as shown in figure 4-11 at B. The eye is also done at this time. Be sure to leave a little white area as a highlight to give the eye some glisten. Simply hatch, then crosshatch with closely spaced lines to do the eye.

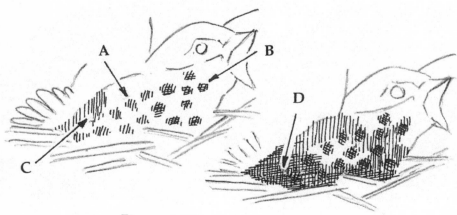

Figure 4-12

(A) Hatch each breast spot. (B) Crosshatch each spot. (C) Hatch the shaded area of the breast. (D) Crosshatch the darker shading.

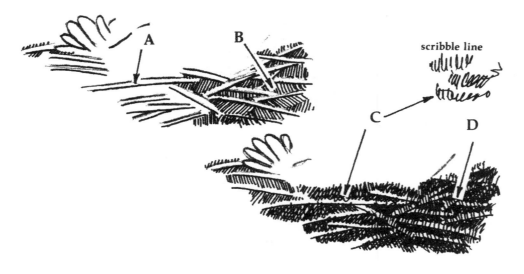

scribble line

Figure 4-13

(A) Underline the bottom of each twig. (B) Hatch the spaces between the twigs. (C) Darken the spaces between the twigs with a scribble line. (D) Hatch over each twig.

Complete your robin's breast by following figure 4-12. First, make the spots with hatching (fig. 4-12 at A), and then crosshatch (fig. 4-12 at B). The darker areas are created by hatching (fig. 4-12 at C) and crosshatching (fig. 4-12 at D). Be sure that you refer to the completed drawing in figure 4-8 as you proceed with yours.

The nest is a jumble of small twigs, fine grasses, and fibers. You simply suggest some of these things in your drawing. Follow figure 4-13. First, underline just the bottom of each twig (fig. 4-13 at A). This suggests some shade. Then, hatch between each twig (fig. 4-13 at B). Be sure you do not cover up the white paper that represents the twigs when you do this. Next, use a scribbled line (fig. 4-13 at C) to go over each of the darks between the twigs, and finally, hatch over each twig with widely spaced hatch marks (fig. 4-13 at D) to tone down the twigs a little. If you don't do this, the twigs will be too light and will tend to attract the viewer's eye, when the bird itself should be the center of interest.

When the ink is dry, lightly erase over the entire drawing with the Pink Pearl or another nonabrasive eraser to remove all the pencil lines that guided your ink drawing.

LESSON 9
Ink Wash Drawing of Hungry

Materials

Waterproof ink washes as prepared in the Chapter 1 section Preparing the Washes; seventy-pound smooth or vellum-finish (slightly rough) paper or watercolor paper; number 5 watercolor brush.

I will be referring to a range of tones in the step-by-step instructions that relate to the recipe for creating the ink tones given in Chapter 1. The lightest tone, one drop of ink in two teaspoons of water, is tone 1. The next lightest, one drop of ink in one teaspoon of water, is tone 2. Three drops in one teaspoon is tone 3, eleven drops is tone 4, and seventeen drops is tone 5. Pure black India ink is tone 6.

Procedure

My finished ink wash sketch of the hungry robin is shown in figure 4-14. Refer to this as you follow the step-by-step instructions to complete your ink wash drawing.

Figure 4-14

Use this ink wash drawing as a guide as you complete your drawing.

Figure 4-15

Use tone 4 to indicate the dark areas on the wings and tail.

Figure 4-16

When the wash is dry, go over the wings and tail with tone 3.

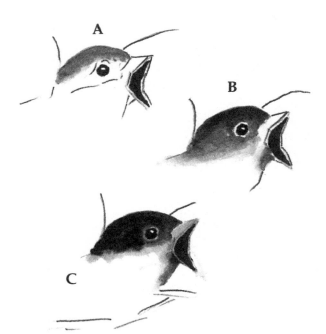

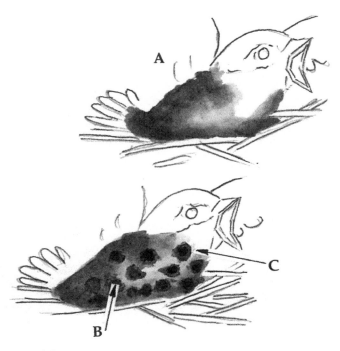

Figure 4-17

(A) Use tone 5 for the eyes and inside the beak. (B) Use tone 3 for the head and chin. (C) Tone 3 is used again over the head and tone 2 is used for the beak.

Draw figure 4-1 on your working paper or trace and transfer it by following the instructions in Chapter 3, Lesson 1: Tracing and Transferring an Outline.

First, use tone 4 to indicate the upper part of the primary feathers on the wings, some of the underwing coverts, and the tail feathers, as shown in figure 4-15. Then, after the ink is dry, go over the entire wing areas with tone 3 until

you have something that resembles figure 4-16.

Next, start the bird's head by doing the eye and the open mouth with tone 5 and the top of the head with tone 3, as shown in figure 4-17A. You will notice that the ink wash creates a hard-looking edge when you paint it on dry paper. To get the soft edge under the eye, paint clear water on the paper under the eye and on the chest area to wet the paper before you use tone 3 to go over the head and chin, as you see in figure 4-17B. When the washes are dry, go over the head area, including the eye and the chin, with another layer of tone 3. Use tone 2 to go over the beak (fig. 4-17C).

Figure 4-18

(A) Use tone 3 for the breast and (B) again for the spots. (C) Touch tone 4 to the center of each spot while it is still a little wet.

Complete the breast on your drawing as shown in figure 4-18. First, use clear water to wet the paper in the center area of the breast so you will get a soft edge. Then place tone 3 on the outer edges of the breast, leaving the center as just white paper (fig. 4-18 at A). When dry, place tone 3 spots on the breast (fig. 4-18 at B). While they are still a little wet, touch some tone 4 to the center of each spot (fig. 4-18 at C).

The nest is completed as you see in figure 4-19. Underline each of the prominent twigs with tone 4 (fig. 4-19 at A). Use tone 2 to paint the area between the twigs—but leave the twigs themselves white (fig. 4-19 at B). Now use tone 3 to paint lines, crisscrossing each other, in the spaces between the twigs (fig. 4-19 at C). You have to use a semimoist brush for this to get the effect of fibers. If the brush is too wet it will simply paint the areas a solid tone. Finally, when the ink is all dry, go over the whole nest, twigs and all, with tone 2 (fig. 4-19 at D).

Figure 4-19

(A) Place a line of tone 4 under each twig. (B) Put tone 2 between the twigs. (C) Draw tone 3 lines in the space between the twigs. (D) Paint tone 2 over the entire nest, including the twigs.

LESSON 10
Other Baby Birds

The songbird's shape can easily be created from three circles if you are drawing your own working figures rather than tracing mine. This circle approach is shown in figures 4-20 and 4-22 and is covered in detail in my earlier book *Wildlife Sketching*. Figure 4-21 is a technical-pen drawing of a baby California jay based on the layout of figure 4-20. I used a fine-point 3×0 technical pen for this. Use the principles that you learned in Lesson 8 to do your version of this subject on either smooth or vellum-finish paper.

The two baby magpies in figure 4-23 were completed using broad-point 4B and sharp HB pencils on vellum-finish paper. Use the principles that we applied in Lesson 7 to do your drawing of the magpies.

Figure 4-20

The structure sketch of a baby California jay, using three circles.

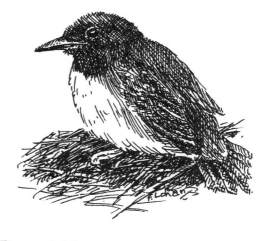

Figure 4-21

A fine-point pen sketch of the California jay.

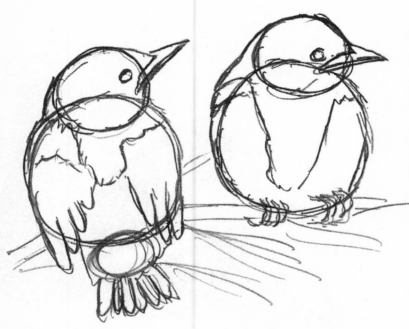

Figure 4-22

The structure sketch of a pair of baby magpies, using circles.

Figure 4-23

A completed pencil drawing of two baby magpies.

5
Two House Sparrows

The next three lessons deal with the same study—a composition including two male house sparrows. These lessons give you step-by-step directions to complete the study, first in pencil, then in pen and ink, and finally in a combination of pen and ink and wash.

This composition would be very static if both birds were in profile, facing the same direction, so I chose to have each of the two subjects facing different directions. I also brought the principle of *foreshortening* into this study by having one of the birds appear closer to the viewer than the other. Foreshortening simply refers to the difference in subject size depending on how close to the viewer's eye the subject is. The farther away, the smaller the subject appears. This essential point in perspective theory is developed at greater length in my book *Wildlife Sketching*.

The working drawing for the next series of lessons is shown in figure 5-1. Copy this figure or trace it and transfer

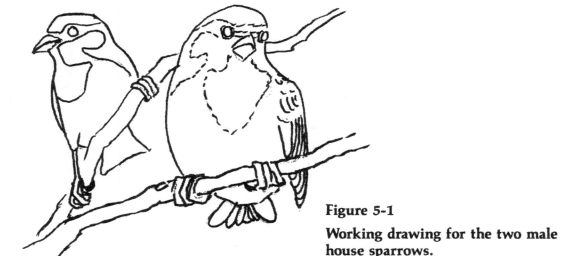

Figure 5-1

Working drawing for the two male house sparrows.

it to your working paper by following the instructions in Chapter 3, Lesson 1: Tracing and Transferring an Outline.

The light pencil outlines that guide the final drawings are rather dark in this book so that they will print well. In actual practice, make these as light as you possibly can on your working paper because, although you can erase them

from a finished ink drawing, and sometimes from a wash drawing, you cannot do so from a finished pencil drawing. Generally, in pencil drawings you do not want the guiding outline to be visible in the finished result, so the outline should be as light as you can make it when you transfer the figure to your working paper.

Pencil Drawing of the Two Sparrows

Materials

Three pencils—sharp HB, broad-point HB, and broad-point 3B or 4B; seventy-pound vellum-finish paper; kneaded eraser.

Procedure

The completed pencil drawing that you will use as a guide as you complete your drawing is shown in figure 5-2.

The first steps in doing this study in pencil are shown in figure 5-3. With your sharp HB pencil, complete the eyes and the beaks. Then use your broad-point HB pencil to do the tops of the birds' heads and the upper half of each branch.

Following figure 5-4, use your broad-point 3B or 4B lightly to add the masks, the sides of the necks, and the tail areas. Use the pencil very lightly to do the shading on the birds' breasts. Do the wing on the right-hand bird by pressing a little harder with the broad-point 3B or 4B. Then finally, pressing hard with the pencil to get a very dark tone, complete the breasts as

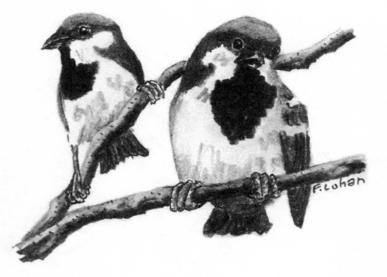

Figure 5-2

Completed pencil drawing of the two sparrows. Use this figure as a guide as you follow the step-by-step instructions.

shown at A in figure 5-4. Your drawing should now resemble figure 5-5. Other than needing a light toning of the feet, figure 5-5 could be used as a finished, loose sketch of the subjects. Notice that the edges are slightly indistinct, which gives a less formal, but quite comfortable, look as compared to the sharp-edged look of figure 5-2.

The final steps involve using the sharp HB pencil to trim up every edge in the drawing as shown in figure 5-6.

Then lightly tone the birds' feet with the HB pencil, and, as a final touch-up, pinch your kneaded eraser to an edge and press it to the tops of the branches in several places to create highlights, as you see at B in figure 5-6. Compare these lightened areas with those at A. Press the kneaded eraser to the breast areas to lighten the tone. Compare the birds' breasts in figure 5-6 with those in the completed drawing, figure 5-2, to appreciate the effect of this lightening.

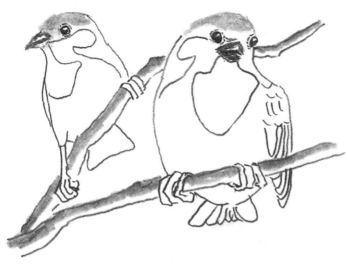

Figure 5-3

Complete the eyes and beaks with a sharp HB pencil. Use a broad-point HB pencil on the crowns and the tops of the branches.

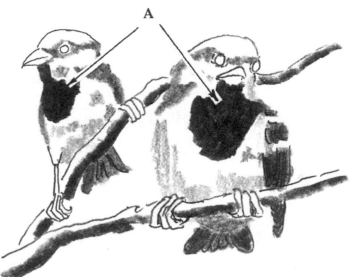

Figure 5-4

Use a broad-point 3B or 4B pencil lightly for the masks, sides of the heads, tails, and the shading on the light breasts. Use the same pencil firmly to do the dark breasts (A), the wings, and the underside of each branch.

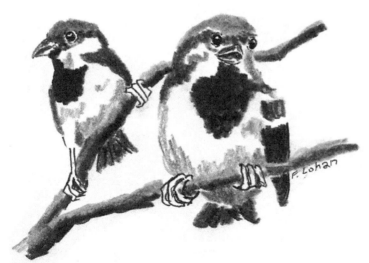

Figure 5-5

Your drawing should now resemble this figure.

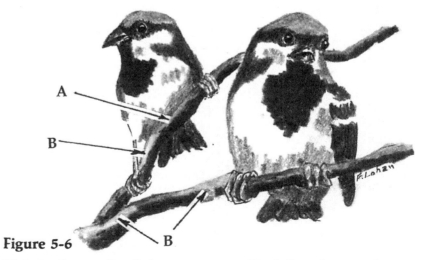

Figure 5-6

This is the result of sharpening up all of the edges with a sharp HB pencil (A) and lightening some of the branch tops with a kneaded eraser to get the effect shown at B.

45

LESSON 12
Pen-and-Ink Drawing of the Two Sparrows

Materials
A fine-point pen (I used my 3×0 technical pen); seventy-pound paper.

Procedure
The completed drawing shown in figure 5-7 will be your guide as you follow the step-by-step instructions to complete your own pen-and-ink drawing of the subjects.

Figure 5-8 illustrates the first step. Use horizontal lines to hatch over the darker areas. Now use vertical lines to crosshatch over these areas and to tone the lighter crowns and undersides of the birds, as well as the tail of the smaller bird (fig. 5-9). The very dark breasts are finished by adding two more overlays of hatching, as you see in figure 5-10. Figure 5-10 at A shows the addition of the *third* of these layers, and at B the *fourth* layer.

The wing and tail of the larger bird are done as illustrated in figure 5-11.

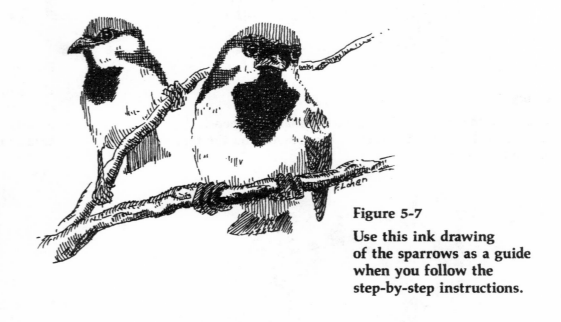

Figure 5-7

Use this ink drawing of the sparrows as a guide when you follow the step-by-step instructions.

First the feather features are placed with lines. Then a layer of hatching is added as at A and, finally, a layer of crosshatching as at B.

Complete your branches as shown in figure 5-12. Start by outlining the top and bottom of each as at A, and then hatch the bottom of each as at B, and add a little crosshatching as at C. Finally, put some hatching on the top of the branches (D). Use the completed drawing in figure 5-7 as your guide to where to place the hatching and crosshatching.

Now all that remains is to erase your pencil guidelines.

Figure 5-8

Hatch the darker areas with horizontal lines.

Figure 5-9

Use vertical lines to cover the medium darks and crosshatch right over the darker passages.

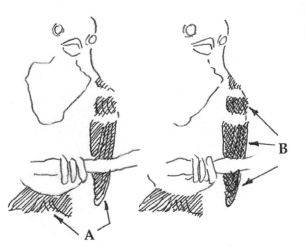

Figure 5-11

(A) Outline some of the feathers, and then hatch over the wing and tail. (B) Crosshatch the wing to darken it a little. Leave the white bars on the wing.

Figure 5-10

Two more layers of crosshatching complete the dark breasts. (A) After the third layer. (B) After the fourth layer.

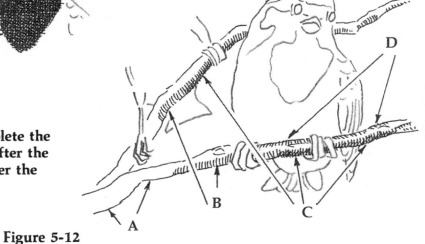

Figure 5-12

(A) Outline the top and bottom of the twigs. (B) Hatch the bottom of the twigs, then (C) cross-hatch. (D) Add a little hatching to the top of the twigs.

LESSON 13
Ink Line and Ink Wash Drawing of the Two Sparrows

In this lesson ink line drawing creates certain details, and ink wash drawing creates the various tones.

Materials

Waterproof ink washes as prepared in the Chapter 1 section Preparing the Washes; seventy-pound paper; number watercolor brush.

Note: as in Lesson 9, I will be referring to the wash tones by number. (One drop of ink in two teaspoons of water is tone 1, one drop of ink in one teaspoon is tone 2, three drops in one teaspoon is tone 3, and eleven drops is tone 4. You will not need tone 5 for this exercise.)

Procedure

Refer to figure 5-13, the finished ink line and ink wash drawing, as you follow the step-by-step instructions to do your drawing.

Draw figure 5-1 on your working paper or trace and transfer it by following the instructions in Chapter 3, Lesson 1: Tracing and Transferring an Outline.

Figure 5-13

The completed ink line and ink wash drawing of the sparrows. Use this figure as a guide as you follow the step-by-step instructions to complete your drawing.

Start this lesson by using your pen and ink to outline the subject and provide some details, as shown in figure 5-14. Your drawing should look like this after you erase all the pencil guidelines.

Next, use tone 2 on the crown of each bird, as shown in figure 5-15 at A. Wait for tone 2 to dry before you apply tone 3, as you see at B, or the two tones will run together and you will lose the demarcation between them on the birds' heads.

The very dark bib on each bird is established in two steps by using tone 4 and, when it dries, using it again right on top of the first application (fig. 5-16).

The tails and visible wings are completed with tone 3, as shown in figure 5-17. When the first application has dried, apply some lines with tone 3 again to emphasize the darker areas.

The delicate shadows on the very light parts of the birds' breasts are established with tone 1 and the dark above the tail on the closer bird with tone 2 (fig. 5-18).

The final step is to complete the branches, as shown in figure 5-19. First a layer of tone 2 is placed on the branches (A). When it has dried, a little tone 3 (B) is touched along the bottom of the branches here and there, over the hatching that indicates the darker shadow.

Figure 5-14

Use pen and ink to complete this much of the drawing before you start using the wash. *Be sure to use waterproof ink!*

Figure 5-15

(A) Use tone 2 on tops of the heads. (B) Use tone 3 as shown for the darker passages after tone 2 has dried. Apply tone 3 twice to get the proper darkness.

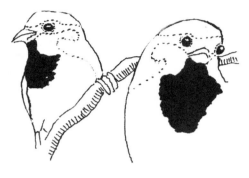

Figure 5-16

Use tone 4 for the bibs. After it dries, apply it again to get the proper darkness.

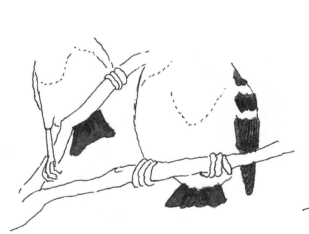

Figure 5-17

Use tone 3 for the wing and tail areas. When it dries, touch up the areas again with tone 3.

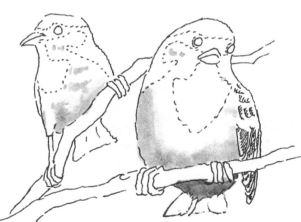

Figure 5-18

Tone 1 is used to create the shadows on the light breasts. Tone 2 is used for the portion of the body above the tail, under the lower branch.

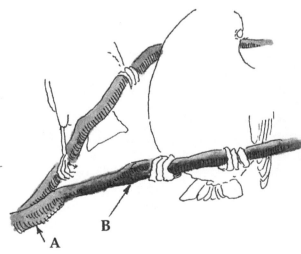

Figure 5-19

(A) Place tone 2 all over both branches. (B) When it is dry, put tone 3 along the bottom of both branches.

LESSON 14
Using the Same Composition to Draw Other Birds

By altering the shape and size of the beak and tail, a given outline of one bird may be used to draw an entirely different bird, as long as the two birds have approximately the same shape and proportions. The two poses used in Lesson 13 are used to draw a towhee and a cedar waxwing in this lesson.

Materials
Sharp and broad-point HB pencils, broad-point 3B or 4B pencil; seventy-pound vellum-finish (slightly rough) paper; kneaded eraser.

Procedure
Transfer the outline of the nearer bird to your working paper and very lightly alter the size and shape of the tail to match that shown in figure 5-20. Now lightly outline the dark and medium areas of the towhee on your drawing and, using the principles we applied to the pencil drawing in Lesson 11, complete your drawing.

The outline of the farther bird is used in a similar manner (fig. 5-21) to prepare a working drawing of the cedar

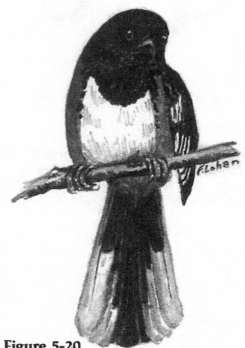

Figure 5-20

One of the house sparrow poses modified to illustrate a towhee. This is a pencil drawing done with HB and 3B pencils.

waxwing, with appropriate outline modifications to the beak, face markings, top of the head, and tail. Good reference materials on birds are essential to create different drawings like this. You must be able to see how

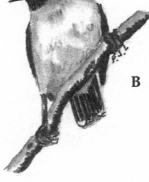

A

Figure 5-21

(A) Modified sparrow outline—beak, crest, and tail markings. (B) Cedar waxwing pencil sketch from the left-hand sparrow in figure 5-1.

B

the body and head markings lie in order to place them properly on your working outline.

Broad-point HB and 3B pencils along with a sharp HB were used to do these drawings.

6
Great Blue Heron

The great blue heron is one of the more widespread of the large herons in the United States. It is a handsome bird, with black head plumes, dark shoulders, dark undersides, and dark spots on each side of its neck. The next three lessons will deal with drawing this bird, first with pencil, then with pen and ink, and finally drawing it on dark paper with ink and using white gouache (a water-based pigment) to bring out the white highlights.

I drew this subject in a walking posture in order to get a pose that is a little less static than one usually found in bird identification books. To get this configuration, I searched out some photographs of walking herons. The bird in the photograph I used was not a great blue heron, but since its proportions were the same as those of the bird I wanted to draw I used it as a model for the outline. Then I made the changes necessary to "clothe" the outline in the proper garb by referring to several other photographs and

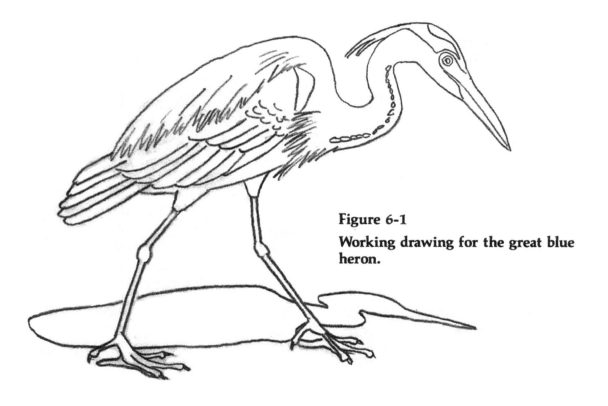

Figure 6-1

Working drawing for the great blue heron.

paintings of the great blue heron.

Figure 6-1 is the working drawing for the next series of lessons. For each lesson, copy the drawing or trace this figure and transfer it to your working paper according to the instructions in Chapter 3, Lesson 1: Tracing and Transferring an Outline.

Pencil Drawing of the Great Blue Heron

Materials

Two pencils—a broad-point 3B or 4B and sharp HB pencil; seventy-pound linen-finish or vellum-finish paper; kneaded eraser. I drew the final study, figure 6-2, on linen paper. You can see the linen texture in the darker passages. The step-by-step figures were drawn on regular vellum-finish paper, so there are no linen texture indications. Either paper will be fine for your work.

Procedure

As you follow the instructions to complete your drawing, use figure 6-2, the completed drawing of the great blue heron, as a guide.

Start with the head and neck, as shown in figure 6-3. Complete the eye and put the line in the beak with your sharp HB pencil. Then use your broad-point 3B lightly for the toning on the beak and neck and around the eye. Use it with a heavy hand to put the dark spots in along the neck. These steps are shown in figure 6-3A.

Next, put the crest in with the broad-point 3B (fig. 6-3B). Finally, as you see in figure 6-3C, use your sharp

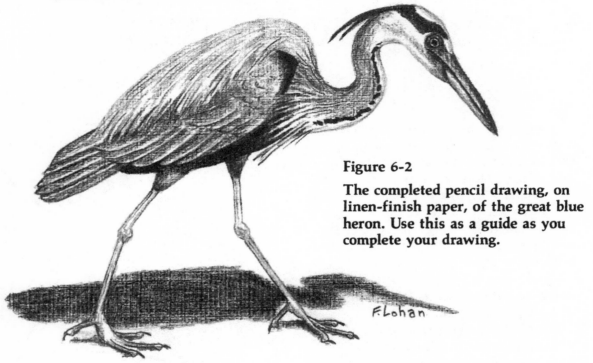

Figure 6-2

The completed pencil drawing, on linen-finish paper, of the great blue heron. Use this as a guide as you complete your drawing.

HB pencil to sharpen all edges.

The back of the bird, full of long plumes, is done with your broad-point 3B pencil, leaving some white paper showing (fig. 6-4 at A). Then, with your sharp HB pencil, trim the back edges as at B, add some plume lines as at C, and finally, press your kneaded eraser to the back to get a little lightening as at D.

Complete the wing by using the broad-point 3B to tone the dark

shoulder, and then, lightly again, use it on the upper half of each feather (fig. 6-5A). Your sharp HB point finishes the wing (fig. 6-5B).

The dark underside is done with the broad-point 3B, as is the shadow under the bird (fig. 6-6 at A and D). The sharp HB defines the edges as shown in 6-6B, and completes the legs. Press the kneaded eraser to the thighs, as was done at C, to lighten them a little.

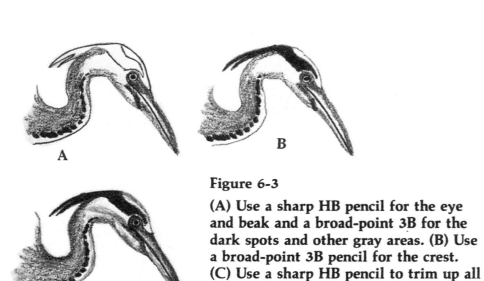

Figure 6-3

(A) Use a sharp HB pencil for the eye and beak and a broad-point 3B for the dark spots and other gray areas. (B) Use a broad-point 3B pencil for the crest. (C) Use a sharp HB pencil to trim up all the edges.

Figure 6-5

(A) Use the broad-point 3B to do the black shoulder and to lightly tone the upper part of each feather. (B) Use your sharp HB pencil to finish each feather.

Figure 6-4

(A) Use a broad-point 3B pencil for the back and lower neck, but leave some white spaces. (B) Use a sharp HB to trim the back line. (C) Use the sharp HB pencil to add a few plume lines. (D) Press your kneaded eraser to the back to lighten it a bit.

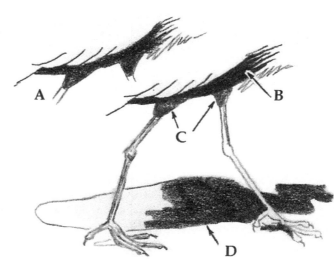

Figure 6-6

(A) Use your broad-point 3B pencil for the dark underside. (B) Sharpen up the dark area with the sharp HB pencil. (C) Lighten the thighs by pressing them with the kneaded eraser. (D) Complete the shadow with the broad-point 3B pencil.

LESSON 16
Pen-and-Ink Drawing of the Great Blue Heron

Materials

Fine-point pen (I used a 3×0 technical pen); seventy-pound paper (either plate-finish or vellum-finish).

Procedure

The completed drawing can be seen in figure 6-7. Use it to guide your work as you follow these step-by-step instructions.

Start your drawing by inking in the eye and some of the head details with hatching and a few lines (fig. 6-8A). As you go along, erase any pencil lines that are no longer needed. This eliminates the unnecessary smudging of graphite on your drawing as you work. Add the crosshatching you see in 6-8B to the top of the head (1) and to the beak (2). Add a few strokes of hatching on the side of the head (3). Now outline the neck plumes as shown in 6-8C at 1 and hatch the neck as you see started at 2.

To complete the back, outline the plumes, and then hatch the back with lines that follow the flow of the plumes

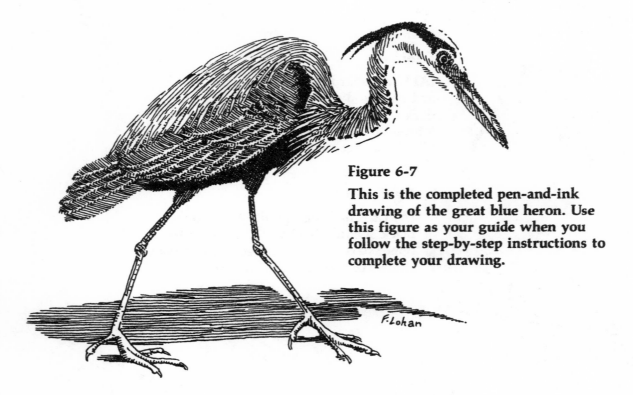

Figure 6-7

This is the completed pen-and-ink drawing of the great blue heron. Use this figure as your guide when you follow the step-by-step instructions to complete your drawing.

F. Lohan

(fig. 6-9). Now outline each feather on the wing with short hatch marks and crosshatch the dark shoulder (fig. 6-10).

Complete the wings with some careful hatching to define the plumes that hang from the bird's back (fig. 6-11). Then carefully hatch each feather

separately, leaving a small strip of white to define each one (fig. 6-12).

Hatch and crosshatch the underside of the heron (fig. 6-13) and using only horizontal lines, do the shadow. Some simple line work completes the legs, as illustrated in figure 6-13.

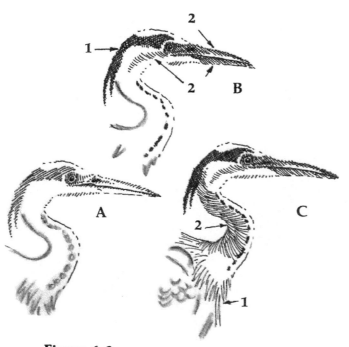

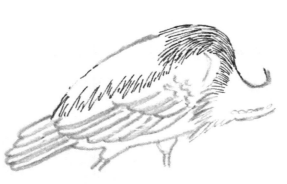

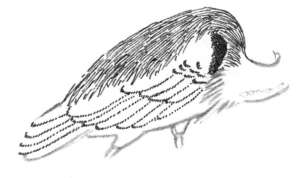

Figure 6-8

(A) The initial line work and hatching.
(B) Crosshatch to establish the darks.
(C) Outline the neck plumes (1) and hatch the neck (2).

Figure 6-9

Outline the back plumes and start hatching the back.

Figure 6-10

Finish hatching the back and outline each feather with very short hatch marks.

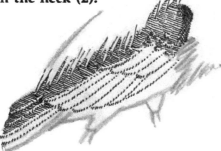

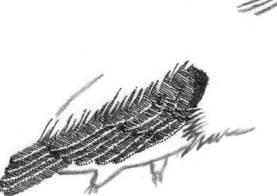

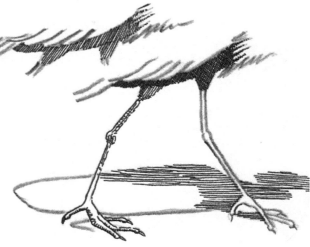

Figure 6-11

Carefully hatch between the back plumes so that they will be distinctly visible.

Figure 6-12

Hatch each feather, but leave a white strip to help define each edge.

Figure 6-13

Hatch, then crosshatch the dark undersides. Use horizontal lines to hatch the shadow, and then complete the legs.

LESSON 17
Drawing on Toned Paper with Ink and Gouache

Materials

Gray or brown paper; fine-point pen (I used a 3×0 technical pen); waterproof ink; white gouache paint; fine watercolor brush that forms a sharp point.

Procedure

The completed ink-and-white-gouache drawing on toned paper can be seen in figure 6-14. This should be your guide as you complete your drawing.

The pen-and-ink part of this study should be completed first. It is done almost exactly like the study in Lesson 16, except that the white areas of the bird's head and neck are indicated with a few ink dots as shown at 1 in figure 6-15A rather than with lines. This simply makes it easier to hide the ink with the white gouache when you paint in the light tones you see in figure 6-15B.

Some of the back plumes are highlighted with the white also as seen at 1 in figure 6-16. A few touches of white on the legs and feet complete this study.

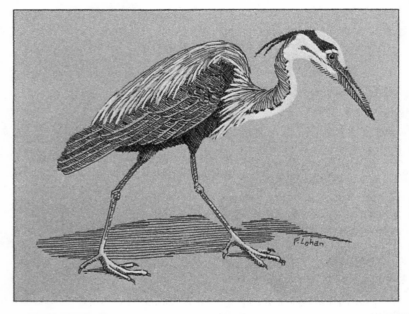

Figure 6-14

This is the completed pen-and-ink and gouache drawing of the great blue heron on gray paper. This will be your guide as you complete your drawing by following the step-by-step instructions.

Figure 6-15

(A) Complete the pen drawing and use ink dots to indicate where the white areas are adjacent to the gray paper as at A(1). (B) Paint the white gouache so it just covers the ink dots as at B(1).

Figure 6-16

Paint a few plumes along the back and at the base of the neck with white gouache (1).

56

LESSON 18
Pencil Drawing of the Least Bittern

Materials
Sharp HB, broad-point HB and 3B pencils; kneaded eraser; seventy-pound vellum-finish paper.

Procedure
This lesson allows you to put into practice some of the things that have been covered in the prior lessons on pencil drawing. Each of these poses can be copied or traced from the working drawings provided in figures 6-17A and 6-18A. I used my kneaded eraser on the bird's neck, lighter wing patches, and legs. Be sure to leave the little pure white markings near the shoulders untouched by the pencil because it is

Figure 6-17

(A) Working drawing for the least bittern. Copy or trace this to use as your working drawing. (B) Completed pencil sketch of the least bittern.

Figure 6-18

(A) Working drawing for another view of the least bittern. Copy or trace it to use as your working drawing. (B) Completed pencil sketch.

LESSON 19
Pen-and-Ink Drawing of the Green Heron

Materials

Sharp pen (I used my 3×0 technical pen); seventy-pound vellum- or plate-finish paper.

Procedure

Copy or trace figure 6-19 to make your working drawing, and then use the completed ink sketch in figure 6-20 as your guide in completing your drawing.

This study involves all of the techniques we used in Lesson 16, but they are now applied to a different subject. In this case, the last thing I did was hatch over the entire wing area to slightly darken the white outlines of each feather. Remember to keep your hatching closely spaced and uniform, and you will have no trouble. Of course, you should erase your pencil guidelines after your ink has dried. I often erase these lines as I go along to prevent smearing the graphite around the drawing.

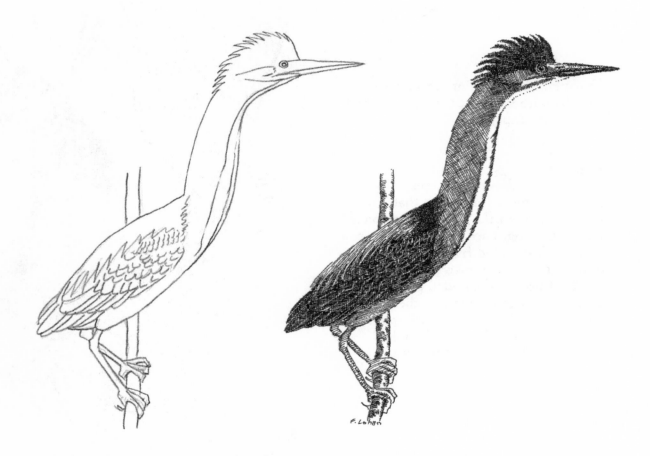

Figure 6-19

Working drawing for the green heron. Copy or trace this figure for your working drawing.

Figure 6-20

The completed pen-and-ink drawing of the green heron.

7
Flying Mallard

Figure 7-1

This is the working drawing for Lessons 20, 21, and 24. Copy or trace and transfer it to your working paper.

The handsome mallard is one of the most common ducks in the United States. Flying male mallards are the subjects for the next five lessons. We will use several different techniques for these studies: pencil and white gouache on toned linen paper, pencil on white linen paper, ink stipple with both fine and coarse points, ink with ink wash, and pencil on vellum-finish paper.

I have already stressed the need for good reference materials, especially when you want to get some action into your drawings of birds. In order to get action, you must know, of course, what the bird looks like in different positions and postures. In this series of studies we consider the duck in three attitudes: having just taken off from the water (Lessons 20, 21, and 24), preparing to land (Lesson 22), and in level flight (Lesson 23). In each case the duck is configured differently, since the bird's muscles are doing different things for

each of the actions. You can get the configurations reasonably correct only by referring to suitable reference materials. In this case, I used some high-speed photographs taken by a naturalist as my guides in preparing the working drawings.

Use figure 7-1, which shows a mallard that has just lifted off from the surface of a pond, as your working drawing. Copy it or trace and transfer it to your paper by using the instructions in Chapter 3, Lesson 1: Tracing and Transferring an Outline.

LESSON 20
Pencil-and-Gouache Drawing on Toned Linen Paper

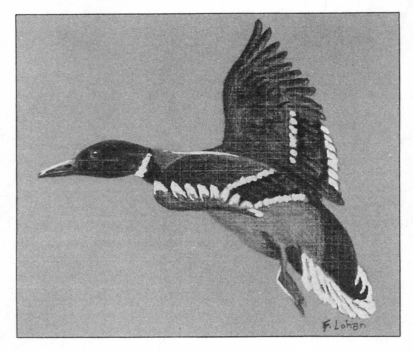

Figure 7-2

The completed pencil-and-gouache drawing of the mallard, on gray linen-finish paper. Use this figure to guide your work as you do your drawing.

Materials

Broad-point HB and 3B or 4B pencils, sharp HB pencil; gray or brown toned paper (I used gray linen-finish paper for the demonstrations); white gouache paint; fine watercolor brush; kneaded eraser.

Procedure

You can see the end result of this study, which combines the pencil and white gouache on toned linen paper, in figure 7-2. This figure will be your guide as you follow the step-by-step instructions and complete your drawing of this subject.

Start by drawing the eye and bill details with your sharp HB pencil (fig. 7-3). Then, with your broad-point 3B or 4B pencil, lay in the moderate darks on the head and near wing. (*Note:* you do not want to press so hard with the softer pencil that you eliminate the linen texture. You are using linen paper so that this interesting texture *will* be visible in the darks.) Next, as shown in figure 7-4, finish the head and the wing with the 3B or 4B pencil. Use the sharp

HB pencil to sharpen up all edges (fig. 7-5). Then use the white gouache to highlight the whites on the throat and the wings and to give a little highlight to the back and tips of the near wing feathers. Without this white emphasis, the wing tips would probably become lost in the surrounding dark tones.

Treat the far wing as you see in figure 7-6, by using the broad-point 3B to indicate the darks (fig. 7-6A), and then use that same pencil, but more

lightly, to tone the entire wing (fig. 7-6B). Sharpen all edges with your sharp HB pencil and, finally, use the white gouache to create the whites on the wing (fig. 7-6C).

Complete the back end of the bird as shown in figures 7-7A and 7-7B. Use your broad-point 3B for the darks and the lighter undersides. If the lighter areas get too dark, touch them with the kneaded eraser to make them lighter. Add the white gouache features.

Figure 7-3

Draw the eye and bill with your sharp HB pencil, and then use your broad-point 3B or 4B pencil to lay in the darks.

Figure 7-4

Finish the head and the near wing with the 3B or 4B pencil.

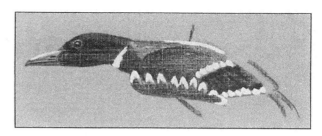

Figure 7-5

Sharpen up the edges with your sharp HB pencil, tone the back with your broad-point 3B, and paint the white areas with white gouache.

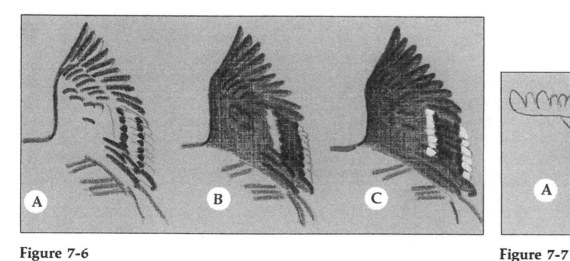

Figure 7-6

(A) Use your broad-point 3B pencil to indicate all the dark features. (B) Complete the darks with the broad-point 3B pencil. (C) Sharpen all edges with your sharp HB pencil, and then add the white gouache features.

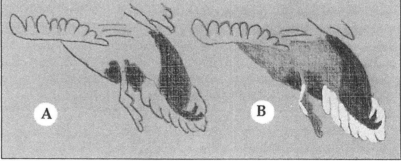

Figure 7-7

(A) Add the darks with your broad-point 3B pencil. (B) Do the lighter areas using your broad-point 3B pencil and the kneaded eraser. Then add the white gouache features.

LESSON 21
Ink Stipple Study of the Mallard

Materials
3×0 technical pen or any fine-point pen; seventy-pound paper.

Procedure
Figure 7-8 is the completed ink stipple drawing of the flying mallard; use it to guide your work as you follow the instructions to complete your stipple drawing.

First, stipple the outline of the entire working drawing, referring to figures 7-9 through 7-14. Then erase the pencil guidelines so you will not smear them over your drawing as you work. Carefully stipple the eye and bill details and start to stipple the darker areas (fig. 7-9). Complete the head area by continuing to stipple the little white spaces to build up the darker tones. Be sure to leave a little highlight on the cheek as you build up the darks (fig. 7-10).

Next, stipple the darker parts of the wings, as you see in figure 7-11. Complete the wings with a less dense layer of the dots so the darker features

Figure 7-8

The completed ink stipple drawing of the flying mallard. As you complete your drawing, use this figure as a guide.

F.Lohan

still show, as illustrated in figure 7-12.

Finally, complete the tail and underside of the duck as shown in figures 7-13 and 7-14. Be careful as you dot in the foot; two or three dots too many and the leg will disappear into the surrounding tone of the body.

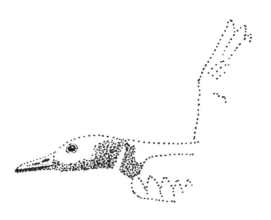

Figure 7-9

Carefully do the eye and beak, and then start stippling the dark head.

Figure 7-10

Try to leave some highlight on the cheek in the dark area.

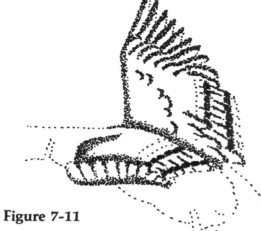

Figure 7-11

Stipple the dark features on the wings.

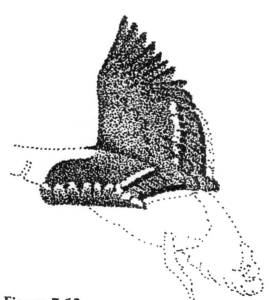

Figure 7-12

Be careful not to obliterate the dark features as you do the final stippling on the wings.

Figure 7-13

Leave the foot white for the moment as you stipple the lower body.

Figure 7-14

Carefully stipple the foot so it does not disappear into the tone of the body. Then add a few dots to the white tail.

LESSON 22
Ink and Ink Wash Drawing of the Mallard

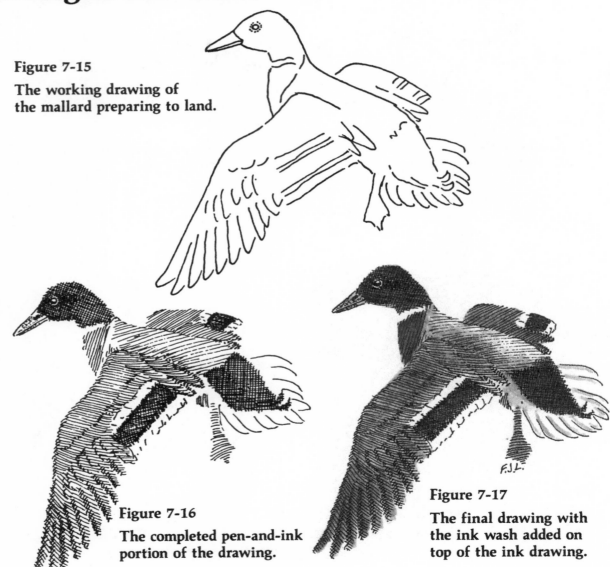

Materials

Fine-point pen with waterproof ink (I used my 3×0 technical pen); seventy-pound paper; ink wash tone 2 (one drop of waterproof ink in one teaspoon of water).

Procedure

Use the working drawing of the mallard preparing to land (fig. 7-15) for your working drawing. Prepare for the ink wash by doing the simple ink drawing shown in figure 7-16. Be sure to use waterproof ink or you may end up with a mess.

Using ink wash tone 2, paint all nonwhite areas of your ink drawing. When this dries, go over the dark areas of the drawing again to strengthen the tone. Do this on the darker areas perhaps four or five times, letting the wash dry between each application, until you are satisfied with the depth of tone (fig. 7-17). You could also use tone 3, three drops of ink in one teaspoon of water, to get the dark tones more quickly. This is a simple drawing to do, so it would benefit you to try it several times to get some practice with using ink wash.

Figure 7-15

The working drawing of the mallard preparing to land.

Figure 7-16

The completed pen-and-ink portion of the drawing.

Figure 7-17

The final drawing with the ink wash added on top of the ink drawing.

64

Pencil Study of the Mallard in Level Flight

Materials

Sharp HB and broad-point 3B and HB pencils; kneaded eraser; seventy-pound vellum-finish paper.

Procedure

Trace or copy figure 7-18. Finish the eye and bill with your sharp HB pencil, and then put some of the dark tone on the head with the broad-point 3B pencil. Use that same pencil to indicate some of the darker passages shown in figure 7-19. Use the broad-point 3B pencil to complete the near wing and the broad-point HB for the far wing (fig. 7-20). I used my kneaded eraser a few times on the far wing and on the belly to get the right tones. The undersides of the mallard's wings are much lighter than the upper surface.

Touch in the white tail feathers with your broad-point HB pencil.

Figure 7-18

The working drawing of the mallard in level flight.

Figure 7-19

Finish the eye and bill with your sharp HB pencil. Use the broad-point 3B pencil to indicate the darks.

Figure 7-20

Complete your drawing with both broad-point and sharp HB pencils and with the broad-point 3B pencil and the kneaded eraser.

LESSON 24
Pencil and Felt-Tip Pen Drawings of the Mallard

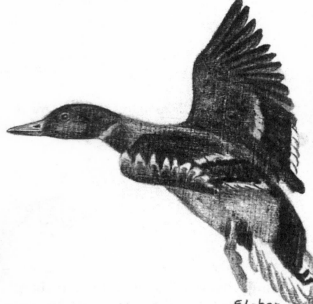

Materials

For the study shown in figure 7-21, use the same pencils you used for Lesson 23. Use a felt-tip pen for figure 7-22. Use seventy-pound vellum-finish paper for both of these studies.

Procedure

The steps you use to complete your pencil drawing of figure 7-21 are the same as those in the previous lesson. The only difference here is in the attitude of the bird. In Lesson 23 the duck was in level flight, and in this lesson it has just taken off, as in the first studies in this chapter. Compare the two studies done on linen paper (figs. 7-2 and 7-21).

To complete the coarse stipple study shown in figure 7-22, use a felt-tip pen or an ink pen with a somewhat broad point. The purpose of this study is to have you see firsthand the difference that the size of the point makes in creating fine detail. In Lesson 21 we used a fine point and had no trouble getting fine gradations of tone. It is much harder to do that with a coarser

Figure 7-21

Pencil drawing on white linen-finish paper of the mallard taking off. Compare this with the pencil drawing on gray linen-finish paper in figure 7-2.

Figure 7-22

A stipple drawing of the mallard done with a felt-tip pen. The large dots do not allow the development of fine detail. Compare this figure with the fine-point pen stipple drawing in figure 7-8.

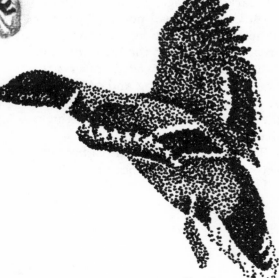

point. A coarser point does allow you to complete the drawing more quickly, however, and may actually be more appropriate for certain applications, such as posters.

66

8 Canada Goose

The Canada goose is a striking bird that can be seen throughout almost all of North America, either as a resident or a migrant. This chapter contains five lessons on drawing the goose using pen, pencil, and ballpoint pen. We will use three different views—one swimming and two flying.

Figure 8-1 shows the working drawing for the first three lessons. For each of these lessons, copy the drawing or trace and transfer it to your working paper following the instructions in Chapter 3, Lesson 1: Tracing and Transferring an Outline. Remember to keep the lines you transfer as light as possible, because although you can erase the guidelines from an ink drawing when you complete it, you cannot do so from a pencil drawing. If your guidelines are too heavy, you may have difficulty achieving the delicate, light effects on the wings that can be seen in figure 8-15.

Figure 8-1

This is the working drawing for the first three lessons on drawing the Canada goose. Copy it, or trace and transfer it to your working paper.

LESSON 25
Pen-and-Ink Drawing of the Swimming Canada Goose

Materials
Fine-point pen (I used my 3×0 technical pen); seventy-pound smooth or vellum-finish paper.

Procedure
As you draw, use as your guide the completed pen-and-ink drawing of the Canada Goose (fig. 8-2). Start with the eye and the bill, since these are the most delicate parts of this small drawing (fig. 8-3A). If they do not work out, you can quickly prepare another working drawing and start again. If you leave them until last and they do not work out, you may find you have spoiled the work of an hour or so. Leave a white ring (as small as possible) around the eye; without the ring the eye will simply disappear into the dark of the bird's head. Start the dark head and neck area with a layer of close hatch marks (fig. 8-3B). Then add another layer as shown at 1 in figure 8-3C, and finally yet another layer to achieve the dark shown at 2 in figure 8-3C. If you make your hatching with the lines spaced too far apart, it may take more

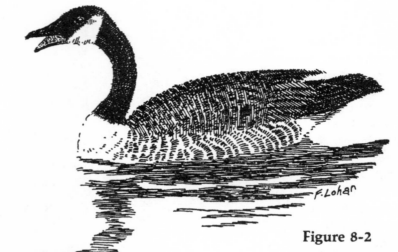

Figure 8-2

The complete pen-and-ink drawing of the Canada goose. Use this figure as a guide as you follow the step-by-step instructions to complete your drawing.

than the three layers of crosshatching to get the proper dark.

Draw the body, referring to figure 8-4. Use short hatch marks to indicate the darker feathers on the goose's body (fig. 8-4A). Then, as illustrated in 8-4B, put a single layer of crosshatching over the upper section of the hatching.

Complete the ends of the wing and

the tail, as shown in figures 8-5 and 8-6, by again indicating the darks with very short hatch marks and crosshatching over the dark areas until they are quite dark. The little white lines, left to delineate each feather in the wing tips and the tail, are very important. Without them these features would be just a solid black.

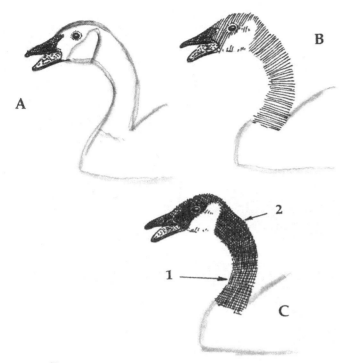

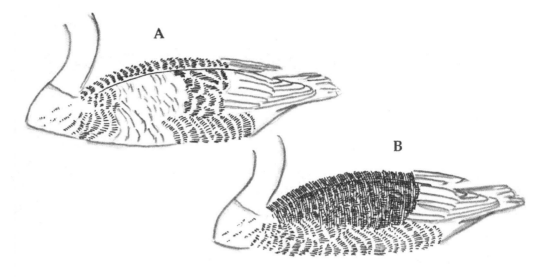

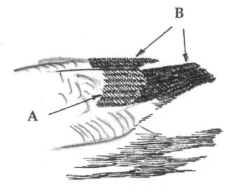

Figure 8-3

(A) Complete the eye and bill first. (B) Hatch the dark head and neck. (C) Crosshatch the head and neck to get the proper dark tone.

Figure 8-4

(A) Indicate the darker markings on the feathers with clusters of short hatch marks. (B) Crosshatch over the wings and back, but not on the side.

Figure 8-5

Carefully indicate the darker markings on the wing tip and tail.

Figure 8-6

(A) Crosshatch over the left portion of the wing with slightly wider spaced lines to make it a little lighter. (B) Crosshatch the wing tip and tail with more closely spaced lines to make them a little darker than the left portion of the wing.

Pencil Drawing of the Swimming Canada Goose

Materials
Broad-point HB and 3B or 4B pencils,
sharp HB pencil; kneaded eraser;
seventy-pound vellum-finish paper.

Procedure
Your guide, as you follow the
step-by-step instructions to complete
your drawing, will be figure 8-7, the
completed pencil drawing of the Canada
goose.

First, using your 3B and sharp HB
pencils, complete the eye and the bill
(fig. 8-8A). Now use your broad-point
3B or 4B pencil to carefully lay in the
dark neck and head, as illustrated in
figure 8-8B. Be especially careful around
the eye; trim the dark with your sharp
HB pencil as you sharpen up the neck
outline. Your drawing should look like
the one in figure 8-8C.

Use your broad-point 3B or 4B pencil
to indicate the dark portions of the
feathers, wing tip, and tail, as you see
in figure 8-9. Complete the body by
using your broad-point HB pencil to
tone over the back, side, wing, and tail,

Figure 8-7

**The completed pencil drawing of the
Canada goose. Use this to guide your
drawing as you follow the step-by-step
instructions.**

and then lightly use the broad-point 3B
to go over *only* that tone on the back,
wing, and tail (fig. 8-10). Do not use it
on the side of the bird, which is
noticeably lighter than the back. To
achieve the proper tone, press your
kneaded eraser on the side to lighten it,
which was done at A in figure 8-10.

The final step is to draw the

reflection with your broad-point 3B or
4B pencil. You will then have something
like the reflection at A in figure 8-11.
The reflection is then sharpened up
with the sharp HB pencil, so that it
resembles that at B. Finally, shape and
press your kneaded eraser on the
reflection near the bird's body at C to
lighten it slightly.

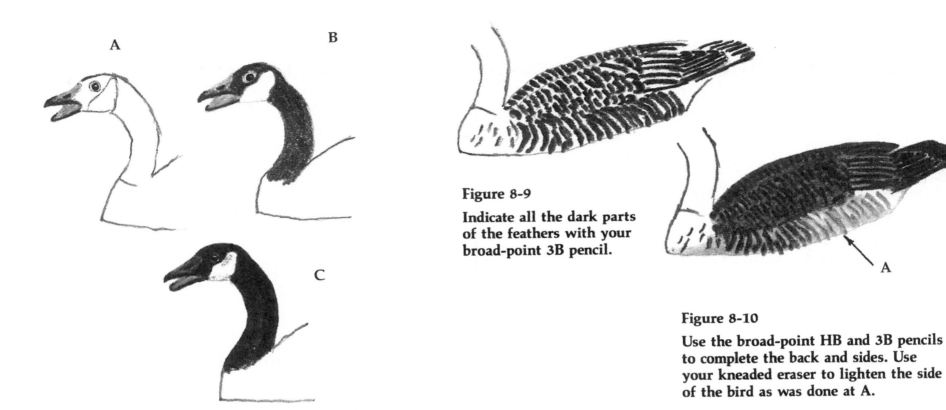

A

B

C

Figure 8-8

(A) Complete the eye and bill with your 3B and sharp HB pencils. (B) Lay in the dark head and neck with your broad-point 3B pencil. (C) Trim up the edges of the head and neck with the sharp HB pencil.

Figure 8-9

Indicate all the dark parts of the feathers with your broad-point 3B pencil.

A

Figure 8-10

Use the broad-point HB and 3B pencils to complete the back and sides. Use your kneaded eraser to lighten the side of the bird as was done at A.

C

B

A

Figure 8-11

(A) Fill in the reflection with your broad-point 3B pencil. (B) Sharpen the edges of each element of the reflection with your sharp HB pencil. (C) Press your kneaded eraser to the reflection near the body to lighten it a bit.

LESSON 27
Ballpoint Pen Drawing of the Swimming Canada Goose

Materials
Medium-point ballpoint pen; seventy-pound smooth or vellum-finish paper.

Procedure
An ordinary ballpoint pen is not sharp enough to do a really satisfactory job on small sketches because its relatively broad point cannot show fine detail. This lesson will show you what you can achieve, however, when you use an ordinary ballpoint for a small study.

Figure 8-12 shows the eye, bill, and darks indicated on the working drawing of the Canada goose. Be very careful doing the eye, as you can easily make it too big or lose the thin white ring that helps define it. If this happens, just prepare another working drawing and try again.

Complete the head and neck by careful crosshatching (fig. 8-13), and then put one layer of crosshatching on the back and the side. Space the crosshatch lines on the side a little farther apart to make it a little lighter than the back. Complete the reflection using only horizontal lines.

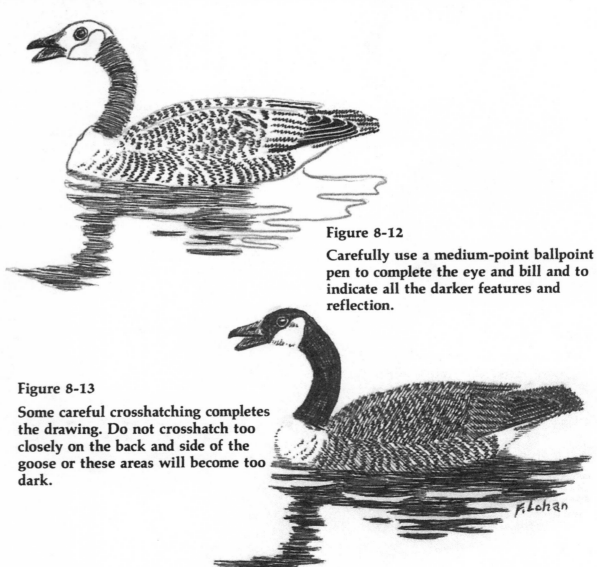

Figure 8-12

Carefully use a medium-point ballpoint pen to complete the eye and bill and to indicate all the darker features and reflection.

Figure 8-13

Some careful crosshatching completes the drawing. Do not crosshatch too closely on the back and side of the goose or these areas will become too dark.

72

LESSON 28
Pencil Drawing of the Flying Canada Goose

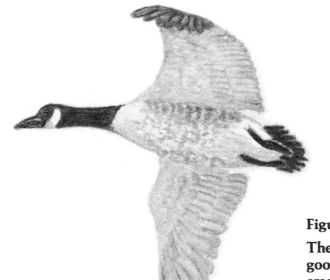

Materials
Sharp B pencil (I used a B lead in my
0.5-millimeter mechanical pencil);
kneaded eraser; seventy-pound
vellum-finish paper.

Procedure
This study is of a flying bird that is
somewhat smaller than the subject in
Lesson 27. With a little careful work
with the pencil, however, you can still
indicate some of the feather texture.

Figure 8-14 is the working drawing.
Copy it, or trace and transfer it to your
working paper. Be sure to keep the lines
of the working drawing very light
because you do not want them to
interfere with the delicate tones in your
finished drawing.

When I finished my study, the bird's
undersides were too dark, so I pressed a
kneaded eraser to the wings and body to
lighten them to the point you see in
figure 8-15. Use the principles that were
explained for the pencil drawing in
Lesson 26 to complete your own
drawing of this subject, referring to
figure 8-15 as a guide.

Figure 8-14

**The working drawing of a flying
Canada goose. Copy this figure, or trace
and transfer it to your paper.**

Figure 8-15

**The completed pencil drawing of the
goose. A sharp B lead and a kneaded
eraser were used.**

LESSON 29
Ink Stipple Drawing of the Flying Canada Goose

Materials

Fine-point pen (I used my 3×0 technical pen); seventy-pound smooth or vellum-finish paper.

Procedure

Figure 8-17 is an interesting and dynamic study that shows a flying Canada goose with its wings at the lower part of their stroke and the outer primary feathers curved upward from the force of the stroke. Copy figure 8-16 or trace and transfer it to your working paper, and then try stippling it with your fine-point pen.

Use the completed stipple drawing, figure 8-17, as your guide in doing your drawing. The same general approach that was used in Lesson 21, the stipple drawing of the flying mallard, should be used here.

Figure 8-16

The working drawing of a flying Canada goose. Copy this figure, or trace and transfer it to your paper.

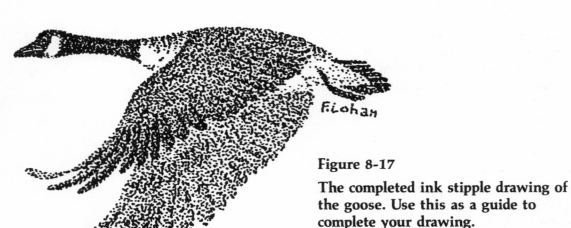

Figure 8-17

The completed ink stipple drawing of the goose. Use this as a guide to complete your drawing.

9
Baltimore Oriole

The Baltimore oriole is one of the prettiest of American songbirds. When the sun strikes its brilliant orange, black, and white plumage, it presents a sight that is not soon forgotten. The next four lessons deal with drawing the oriole with pencil on linen paper, and in various ways in ink.

Figure 9-1 shows the working drawing for Lessons 30 through 32. Copy it, or trace and transfer it for each lesson, according to the instructions in Chapter 3, Lesson 1: Tracing and Transferring an Outline.

The challenge in this series of lessons with our black-and-white medium is to suggest that there is a difference in tone between the white on the wings and the orange that covers the rest of the light parts of the bird. The orange tone is suggested by creating a light gray tone with the pencil. With the pen, the light gray is suggested by hatching with thin lines spaced farther apart. When using ink wash, we simply use a diluted wash to produce the light gray. In all cases, we let the white paper itself represent the white details on the bird.

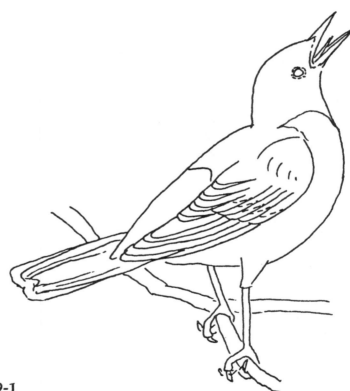

Figure 9-1

This is the working drawing of the Baltimore oriole. Copy it, or trace and transfer this figure to your working paper, and then follow the step-by-step instructions to complete your drawing of the subject.

Pencil Drawing on Gray Linen Paper

Materials

Broad-point HB and 3B or 4B pencils, sharp HB pencil; gray-toned paper (I used gray linen-finish paper); white gouache; number 5 watercolor brush.

Procedure

In the completed pencil drawing of the Baltimore oriole (fig. 9-2), the texture of the linen paper is visible in the dark areas of the figure. If you do not use linen-finish paper, your own drawing will not show this texture. The white features on the wings were put in with white gouache paint and a number 5 watercolor brush after all of the pencil work was completed.

Start your drawing of this subject referring to figure 9-3 and, using your sharp HB pencil, draw the eye and beak. Then use your broad-point 3B or 4B pencil to lay in the dark head and back (fig. 9-3 at B). Then, with your sharp HB pencil, bring these darks right up against your working pencil lines, as was done in figure 9-3 at C. This is what I mean when I say to "sharpen up" your dark areas.

Next, carefully use your broad-point

Figure 9-2

The completed pencil drawing of the oriole on linen-finish paper. White gouache was used to emphasize the white portions of the wing feathers. Use this figure to guide your drawing of the subject.

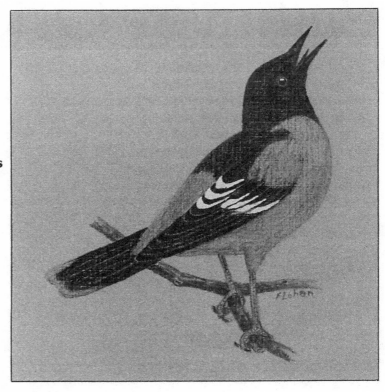

3B to place the dark wing markings (fig. 9-4), being sure to leave white slivers between the wing feathers. Using the sharp HB, sharpen the wing darks; make the slivers that show the wing feathers as narrow as you can without losing them (fig. 9-5 at A).

Now use the watercolor brush and the white gouache paint to add the

white wing details (fig. 9-5 at B).

To suggest the orange parts of the plumage, tone the orange areas with your broad-point HB pencil, as shown in figure 9-6 at A. Carefully sharpen the edges with the sharp HB at B, and finally, as you see at C, press your kneaded eraser to the orange areas to take the tone down a little.

Figure 9-3

(A) Complete the eye and beak with a sharp HB pencil
(B) Lay in the darks with a broad-point 3B or 4B pencil.
(C) Use your sharp HB pencil to sharpen up the edges of the dark areas.

Figure 9-4

Carefully use your broad-point 3B or 4B pencil to indicate the dark wing and tail feathers. Leave light slivers between the feathers.

Figure 9-5

(A) Sharpen up all darks with your sharp HB pencil. Trim the light slivers between the feathers, making them as narrow as you can. (B) Use white gouache and your watercolor brush to paint the white parts of the wing feathers.

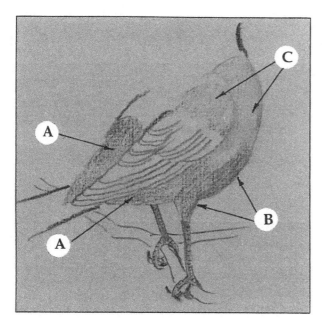

Figure 9-6

(A) Use your broad-point HB pencil lightly on the orange parts of the plumage, including the tip of the tail. (B) Sharpen all edges with the sharp HB pencil. (C) Press your kneaded eraser on the orange areas to lighten the gray tone.

77

LESSON 31
Ink and Ink Wash Drawing of the Baltimore Oriole

Materials
Fine-point pen (I used my 3X0 technical pen); seventy-pound smooth or vellum-finish paper; ink wash tone 2 (one drop of ink in one teaspoon of water); number 5 watercolor brush.

Procedure
Figure 9-7 is the completed ink and ink wash drawing of the Baltimore oriole. Use it to guide you as you follow the step-by-step instructions to complete your drawing of this subject.

Your first step is shown in figure 9-8A. Start hatching the dark head and neck after you complete the eye and beak. Next, add a layer of crosshatching to these darks, referring to 9-8B. A third layer of crosshatching, shown in figure 9-8C, will complete these darks if you have made your hatching and crosshatching with closely spaced lines. If your lines were farther apart than mine, you may have to add a fourth layer of crosshatching to get the proper dark tone.

The wings and tail are handled with

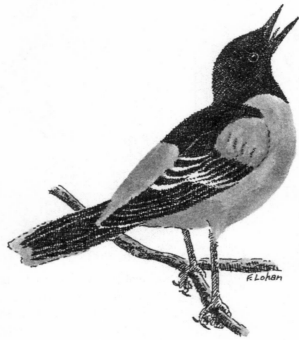

Figure 9-7

Use this ink and ink wash drawing of the oriole to guide your drawing when you follow the step-by-step instructions.

hatching and crosshatching (fig. 9-9). After you do the first layer of crosshatching, go over the wing and tail with a more widely spaced layer of crosshatching. This time, however, cover the white slivers between the

feathers to tone them down a little, as shown in 9-9B at 1.

After drawing the legs and branch with the pen, add one layer of wash to the branch and to the orange parts of the bird (fig. 9-10).

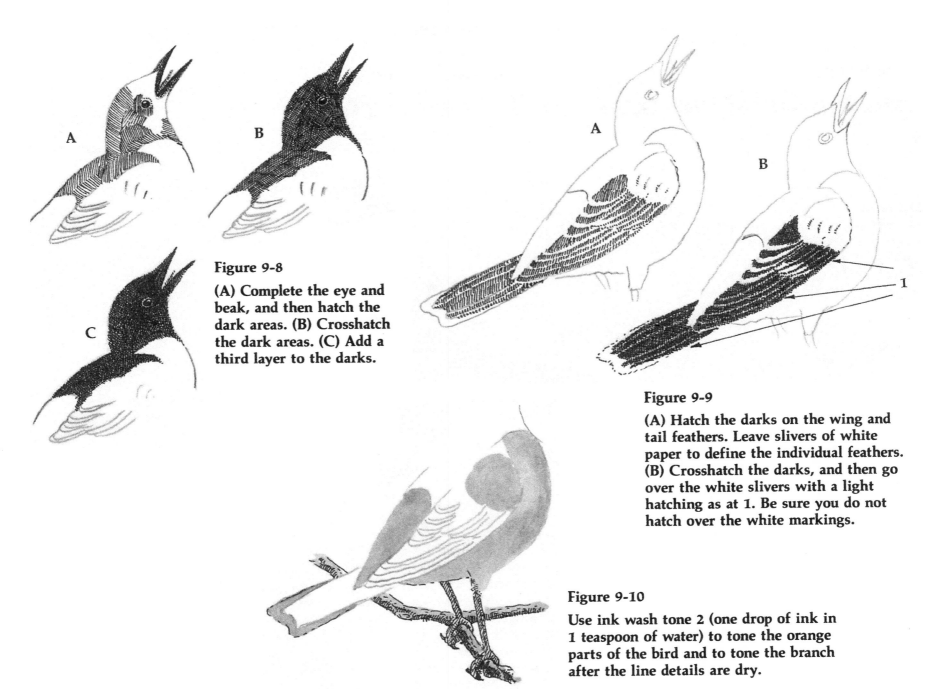

Figure 9-8

(A) Complete the eye and beak, and then hatch the dark areas. (B) Crosshatch the dark areas. (C) Add a third layer to the darks.

Figure 9-9

(A) Hatch the darks on the wing and tail feathers. Leave slivers of white paper to define the individual feathers. (B) Crosshatch the darks, and then go over the white slivers with a light hatching as at 1. Be sure you do not hatch over the white markings.

Figure 9-10

Use ink wash tone 2 (one drop of ink in 1 teaspoon of water) to tone the orange parts of the bird and to tone the branch after the line details are dry.

LESSON 32
Pen-and-Ink Drawing of the Baltimore Oriole

Materials
Fine-point pen, medium-point pen (I used my artist's pen for the coarser lines and a sharp crowquill for the finer ones); seventy-pound smooth or vellum-finish paper.

Procedure
Use the finished pen drawing in figure 9-11 as your guide as you follow the instructions to complete your drawing.

The medium-point pen will place much more ink on your paper than the very fine point; therefore, you must be concerned about two things. First, the medium lines will not dry as rapidly as the fine lines, so you must be careful not to smear the wet ink. Second, erasing the pencil guidelines when you are finished will probably smear a grayish tone on your drawing from the ink. It is important to make your working drawing as light as possible to minimize any damage from the erasing that may be required at completion.

Start, as usual, by completing the eye and beak, and then use the medium

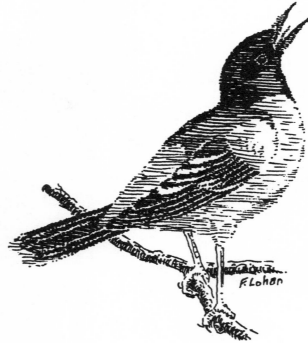

Figure 9-11

The completed pen drawing of the Baltimore oriole. Use it to guide your drawing.

point to lay closely spaced horizontal lines on the dark head and neck areas, as you see in figure 9-12. When the lines are dry, add lines between some of them to achieve a little roundness and tone variation (fig. 9-13).

The horizontal lines that show the wing and tail-feather details (fig. 9-14) are also done with the medium point.

Trim up the slivers of white between the wing and tail feathers with dots. Then draw horizontal lines with your fine point to show a little outline shading on the bird's breast (fig. 9-15).

Your fine point and some more widely spaced lines complete the orange passages on the breast, back, and tail (fig. 9-16).

80

Figure 9-12

Complete the eye and beak, and then put horizontal hatching on the dark head and upper back.

Figure 9-13

Add lines on the head and back to create roundness and variation in the dark tones.

Figure 9-14

Detail each wing and tail feather with horizontal lines.

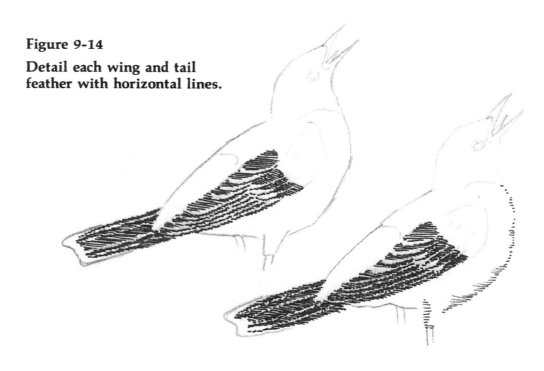

Figure 9-15

Trim up the white slivers that separate the feathers. Make them very narrow. Use a fine point to indicate the breast outline.

Figure 9-16

Use your fine point and horizontal lines to tone the orange parts of the bird. Then complete the legs and branch with the same fine point.

LESSON 33
Pen-and-Ink Drawing of the Baltimore Oriole and Nest

Figure 9-17

The working drawing of the oriole and nest.

Materials
Fine-point pen (I used my 3×0 technical pen); seventy-pound smooth or vellum-finish paper.

Procedure
The nest of the Baltimore oriole is an interesting woven sack that is attached near the tip of a branch. Figure 9-17 is the working drawing for a study of the nest and a nearby oriole. In this study, the bird is drawn quite small, so there is no way to develop much feather detail. At this scale, all you can do is to indicate the tone placements. Use figure 9-18 as your guide to complete your rendition of this drawing, using some of the things we covered in prior lessons.

Figure 9-18

The completed pen drawing of the oriole and nest. Refer to it as you complete your drawing of this subject.

10 Downy Woodpecker

The downy woodpecker is a familiar bird throughout the United States and most of Canada. The next three lessons cover how to draw this woodpecker using pen only, pencil only, and ink wash only. This chapter includes lessons for drawing two other woodpeckers: the regal pileated woodpecker, the second largest woodpecker in North America, and the ubiquitous flicker. The techniques you learn in doing the downy woodpecker drawings are to be applied when you do these other drawings, too—one in ink and the other in ink wash and in pencil.

Figure 10-1 is the working drawing of the downy woodpecker. Use this figure for the first three lessons in this chapter. Copy it for each lesson, or trace and transfer it according to the instructions in Chapter 3, Lesson 1: Tracing and Transferring an Outline.

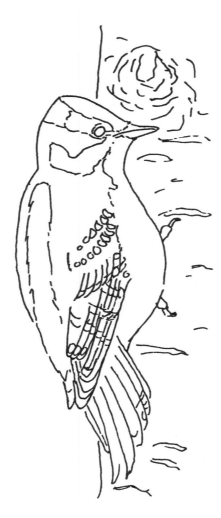

Figure 10-1

This is the working drawing of the downy woodpecker. Use it for the next three lessons by copying it or tracing and transferring it to your paper for each lesson.

83

Fine-Point Pen-and-Ink Drawing of the Downy Woodpecker

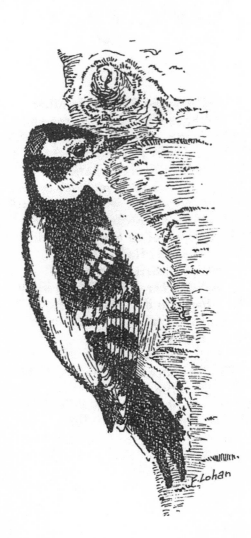

Materials

Fine-point pen (I used my 3×0 technical pen); seventy-pound smooth or vellum-finish paper.

Procedure

Crosshatching creates the blacks shown in figure 10-2, the completed pen drawing of the downy woodpecker. The first step is to complete the eye and beak (fig. 10-3). Next, as you see in figure 10-4, the darker areas are covered with a layer of hatching. Be careful to dodge around all the little white marks on the wings so you do not inadvertently hatch over them.

When the first layer of hatching is complete (fig. 10-4 at A), do a second layer over only the black parts of the bird (fig. 10-4 at B). For the moment, leave the red patch on the back of the head as it is, with just one layer of ink (fig. 10-4 at C). Your third layer of crosshatching over the black passages, and a second over the red patch, complete the head and back, as is apparent in figure 10-5.

The wings contain some intricate

Figure 10-2

The completed pen drawing of the downy woodpecker. Use this as your guide as you complete your drawing by following the step-by-step instructions.

white marks that you do not want to lose, so carefully outline each feather and hatch around the white marks (fig. 10-6). Do one feather at a time when you do this sort of wing and tail detail. A second and third layer of crosshatching, as shown in figure 10-7, completes the bird.

Develop the detail of the tree bark in two steps as I show in figure 10-8. First, put in the small irregularities of the bark, and then tone the bark with hatching, especially along the bird's throat, neck, and breast. This toning helps define the bird's shape.

84

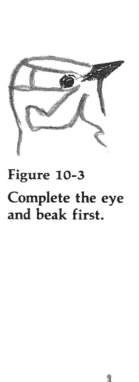

Figure 10-3

Complete the eye and beak first.

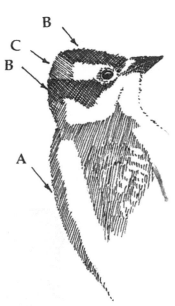

Figure 10-4

(A) Cover the darks on the head and back with a layer of closely spaced hatching. (B) Crosshatch the darks with a second layer. (C) Keep the red patch lighter than the black tones.

Figure 10-5

Complete the blacks with a third layer of crosshatching and the red patch with a second layer.

Figure 10-6

After outlining each feather with ink, hatch the darks, one feather at a time.

Figure 10-7

Add one or two more layers of crosshatching to each feather.

Figure 10-8

(A) Put in the dark markings on the trunk with short hatch marks. (B) Tone the trunk with horizontal hatch marks.

LESSON 35
Pencil Drawing of the Downy Woodpecker

Materials
Broad-point 3B, broad-point and sharp
HB pencils; kneaded eraser;
seventy-pound vellum-finish paper.

Procedure
The completed pencil drawing of the
bird is shown in figure 10-9. To begin,
draw the eye and beak as shown in
figure 10-10. Then block in the dark
tones with your broad-point 3B pencil
(fig. 10-11). Your broad-point HB is
used to draw the red crest on the back
of the bird's head. Care is required to
dodge around the white spots on the
upper part of the bird's wing. You want
to keep all pencil marks off these spots
so that they show up clearly and crisply
when you sharpen all the dark edges, as
shown in figure 10-12. (The same care
is required to get the white marks on
the wings to remain clear and crisp, as
you see in figure 10-14.)

Proceed, as I show in figure 10-13,
outlining one feather at a time with
your sharp 3B pencil and indicating
where the white patches lie. Then

Figure 10-9

**The completed pencil drawing of the
downy woodpecker. Use this as your
guide when you follow the instructions
to complete your drawing.**

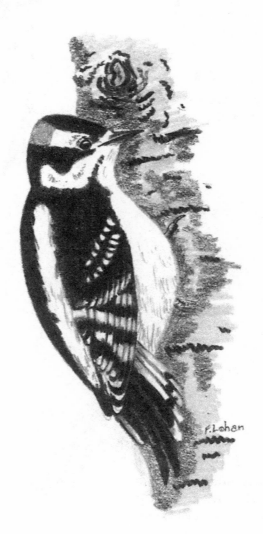

darken the black areas. When all the
feathers are complete (fig. 10-14), shape
and press your kneaded eraser across
the white bars on the wings. This will
tone down the black outlines of each
feather a little, as you see at A.

The tree trunk is done in the three
steps shown in figure 10-15. Put in the
dark details and then do the darker
shading with your broad-point 3B
pencil. Finally, put in the lighter shading
with your broad-point HB pencil.

Figure 10-10

Complete the beak and eye.

Figure 10-11

Use your broad-point 3B pencil to block in the darks. Use your broad-point HB pencil on the red part of the head at A.

Figure 10-12

Use your sharp HB pencil to sharpen up the edges of the darks.

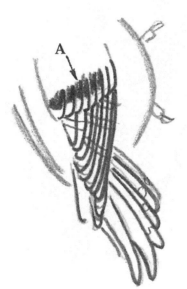

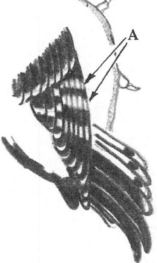

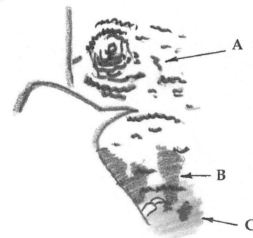

Figure 10-13

Outline each feather with your sharp 3B pencil. Carefully indicate where the white patches lie. Blacken the darks one feather at a time as at A.

Figure 10-14

Darken all of the black feathers with your broad-point 3B pencil, and then sharpen the edges with the sharp HB. Finally, shape and press your kneaded eraser across the white bars as at A.

Figure 10-15

(A) Use your broad-point 3B pencil to put in the darker marks. (B) Use your broad-point 3B pencil lightly to tone the darker parts of the bark. (C) Your broad-point HB pencil does the lighter bark.

LESSON 36
Ink Wash Drawing of the Downy Woodpecker

Materials
Waterproof ink washes, tone 2 (one drop of ink in one teaspoon of water), and tone 4 (eleven drops of ink in one teaspoon of water); number 5 watercolor brush; seventy-pound smooth or vellum-finish paper; white gouache paint.

Procedure
The steps to complete the ink wash drawing of the downy woodpecker (fig. 10-16) are very much the same as those required to complete the ink or the pencil drawings. Start with the eye and beak, referring to figure 10-17, using wash tone 4. Dot some of this tone on the eye several times, letting it dry between each application. Use the same tone, number 4, to block in the darks on the bird's head and back (fig. 10-18). Be as careful as you can to leave the white markings on the upper wings, but should these markings disappear, you can restore them after you complete the wash work by using some white gouache paint. It will take several applications of wash tone 4 to get the

Figure 10-16

The completed ink wash drawing of the downy woodpecker. Use this figure as your guide when you complete your drawing following the step-by-step instructions.

deeper black of the head, back, and wings. Be sure to let each application dry before you do the next one. Figure 10-19 shows three applications of tone 4. The wings and tail feathers are done one at a time after you outline them with wash tone 4 (fig. 10-20). Several applications of the tone are required to develop the darks to the point shown in figure 10-21.

The tree trunk is done in three steps, as shown in figure 10-22. Tone 4 is used for the small bark markings at A; the same tone is used to put in the darker toning at B; and tone 2 is used for the lighter areas at C. Also use tone 2 to shade in the white parts of the bird.

When all the washes are dry, use your white gouache paint to trim up the little white marks on the bird's upper and lower wing.

Figure 10-17

Carefully complete the eye and beak with wash tone 4.

Figure 10-18

Use wash tone 4 to block in the black areas. This figure shows the first application of the wash tone.

Figure 10-19

When each layer of the wash dries, go over it with another layer of tone 4 to deepen the blacks.

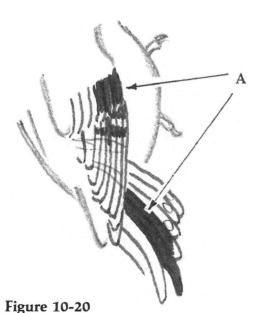

Figure 10-20

Carefully outline each feather with a line of wash tone 4, and then cover each feather with the same tone, as at A.

Figure 10-21

As each layer of tone dries, add another to deepen the black feathers.

Figure 10-22

(A) Use tone 4 to put in the bark features. (B) Use tone 4 to wash in the darker bark areas. (C) Use tone 2 for the lighter bark areas and for the shades in the white parts of the bird.

LESSON 37
Pen-and-Ink Drawing of the Pileated Woodpecker

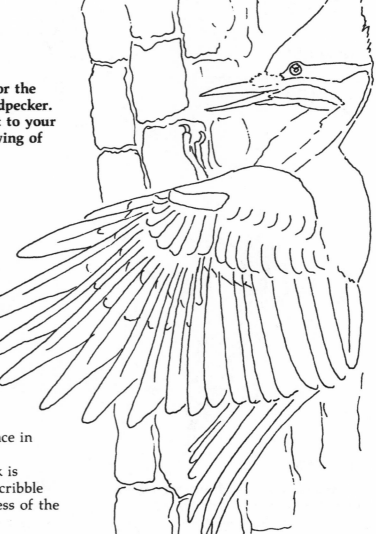

Materials

Fine-point pen (I used my 3×0 technical pen); seventy-pound smooth or vellum-finish paper.

Procedure

Copy or trace the working drawing shown in figure 10-23. This drawing is large enough so that each wing and tail feather can quite easily be shown in your drawing. Leave a small sliver of white paper between each feather to indicate the quills on the outer wing feathers as shown in figure 10-24, the completed drawing of the woodpecker. Hatch the feathers one at a time, refer to figure 10-25, leaving slivers of white paper, as you see at A. When you add the second layer of crosshatching, figure 10-26 at A, keep these white slivers but trim them down as narrowly as you can. Finally, when you add the third layer of crosshatching, go right over the white slivers to tone them down as at B.

Use only two layers of crosshatching in the woodpecker's red crest and mustache so that the difference in color

Figure 10-23

This is the working drawing for the pen sketch of the pileated woodpecker. Copy it, or trace and transfer it to your working paper to do your drawing of this subject.

will be indicated by the difference in tone.

The texture of the tree trunk is shown by lines, hatching, and scribble marks that suggest the roughness of the bark (fig. 10-24).

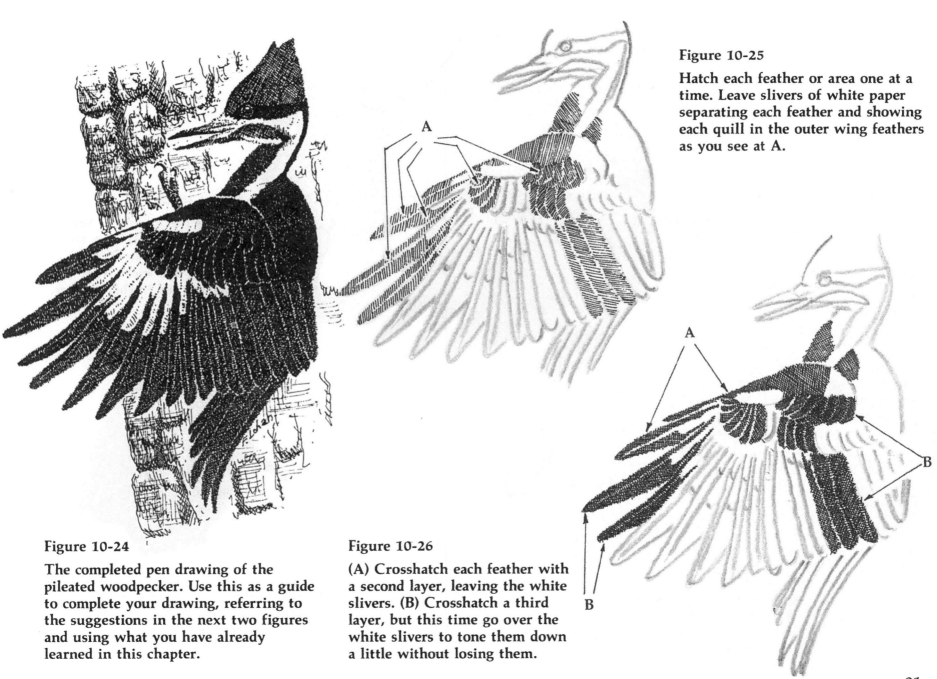

Figure 10-25

Hatch each feather or area one at a time. Leave slivers of white paper separating each feather and showing each quill in the outer wing feathers as you see at A.

Figure 10-24

The completed pen drawing of the pileated woodpecker. Use this as a guide to complete your drawing, referring to the suggestions in the next two figures and using what you have already learned in this chapter.

Figure 10-26

(A) Crosshatch each feather with a second layer, leaving the white slivers. (B) Crosshatch a third layer, but this time go over the white slivers to tone them down a little without losing them.

91

LESSONS 38 and 39
Two Drawings of the Flicker

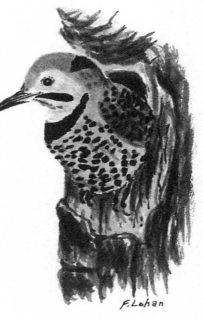

Materials
Ink washes tone 2 (one drop of ink in one teaspoon of water) and tone 4 (eleven drops of ink in one teaspoon of water); broad-point HB and 3B pencils, sharp HB pencil, sharp 2B pencil; kneaded eraser; seventy-pound vellum-finish paper.

Procedure
Figure 10-27 is the working drawing for these two studies of the flicker peeking out of a nest hole. Copy it, or trace and transfer it to your paper, and then use what you have learned in this chapter to complete the two studies—one wash drawing, shown in figure 10-28, and one pencil drawing, shown in figure 10-29.

Figure 10-27

This is the working drawing of the flicker. Copy it, or trace and transfer it to your paper for each study.

Figure 10-28

This is the completed wash drawing of the flicker. Use it as a guide as you do your drawing and apply what you have learned in this chapter.

Figure 10-29

The completed pencil drawing of the flicker. An HB, a 2B, and a 4B pencil were used. Use this figure and the things you have learned in this chapter in completing your own pencil study.

11
Blue Jay

This noisy but handsome blue, white, and black bird is familiar to many North American residents. Lessons 40 through 43 are devoted to drawing the blue jay with pen and ink.

Pen-and-ink drawing can be done in various ways: with carefully placed hatch marks and crosshatching; with meticulous stipple that has tones built up by dots of ink; with a rapid scribble stroke to establish tone patterns quickly; and with fine pen points or with coarser ones that make the inclusion of fine detail impossible. Each of these methods produces a different effect. In the next four lessons, all of these ways of putting ink on paper to create an image will be demonstrated. If you do all of these lessons, you will see for yourself that when you use the coarser points it's a trade-off—what you gain in time saved you lose in ability to render detail.

Figure 11-1 is the working drawing for all of the lessons in this chapter. Copy it, or trace and transfer it following the instructions in Chapter 3, Lesson 1: Tracing and Transferring an Outline.

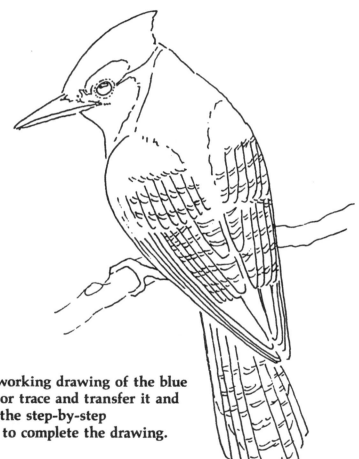

Figure 11-1

This is the working drawing of the blue jay. Copy it or trace and transfer it and then follow the step-by-step instructions to complete the drawing.

Heavy Ink Line Drawing of the Blue Jay

Materials

Medium, or coarse, pen point (I used my artist's fountain pen); seventy-pound smooth or vellum-finish paper.

Procedure

In this study you will be outlining, with straightforward hatching and crosshatching to suggest the various tones of the blue jay's plumage. Figure 11-2 shows the completed drawing, done with a medium-point artist's fountain pen.

Complete the eye and beak, and then add the black features to the bird's head as in figure 11-3. Next, outline the bird and hatch the dark head, neck, and shoulders. After the ink has dried, crosshatch these dark blue areas, as shown in figure 11-4.

The wings are started, as shown in figure 11-5, by outlining each of the feathers in ink. Then put in all of the black markings (fig. 11-6 at A) before you carefully hatch the long primary feathers and the secondary ones around the black markings, as shown at B. Treat each feather individually and be sure

Figure 11-2

The completed pen drawing using a medium pen point. Use this figure to guide your work as you follow the instructions.

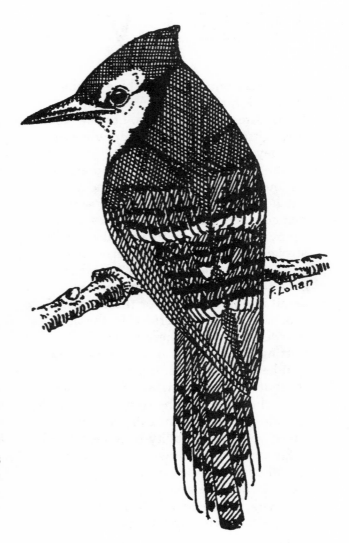

that you don't get carried away and hatch over the white tips on some of the feathers. It is easy to do. If you make this mistake simply paint the white area in with the white gouache when your drawing is finished.

The tail is completed as shown in figure 11-7. After you have outlined each feather, put in the dark black bars as at A, and, when they have dried, do the hatching over the blue parts of the feathers as shown at B. Refer to figure 11-2 for guidance on completing the branch.

Figure 11-3

Complete the eye and beak first, and then do the black markings on the head and neck a solid black.

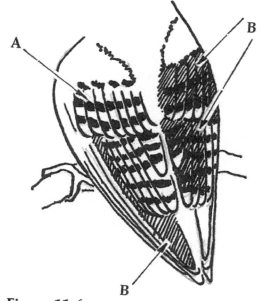

Figure 11-4

(A) Outline the bird and hatch the darker parts of the head, back, and shoulders. (B) Crosshatch the dark areas.

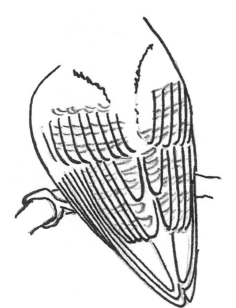

Figure 11-5

Outline each feather in ink.

Figure 11-6

(A) Put in the dark bars on the wings. (B) Hatch over each feather, one at a time. Be sure to skip over the white tips of some of the feathers.

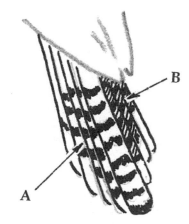

Figure 11-7

(A) After outlining each tail feather, put in the black bars. (B) Hatch over each feather, one at a time. Leave the tips of the outer feathers white.

95

LESSON 41
Fine Ink Line Drawing of the Blue Jay

Figure 11-8

The completed fine-point pen drawing of the blue jay. Refer to this figure as you follow the step-by-step instructions to complete your drawing.

Materials
Fine-point pen (I used my 3×0 technical pen); seventy-pound smooth or vellum-finish paper.

Procedure
The steps involved in completing the fine-point pen hatching and crosshatching for this lesson are the same as those in Lesson 40. More time is required, however, for this drawing because you will be placing less ink on the paper with each stroke; therefore more strokes will be required to obtain a given dark shade. For this study we will eliminate the outline because the tones do not need a specific outline to create the form of the bird. In general, unless you want outlines for a reason, such as for some of the stylized drawings covered earlier in the book (figure 3-12, for example), you will achieve a more interesting effect if you do not use outlines when they are not required to help the viewer understand your drawing. Compare figures 11-2 and 11-8 to see the difference between a drawing with and without an outline.

Figure 11-8 shows the completed fine-point pen drawing of the subject.

Note that the separation between the feathers is indicated by narrow slivers of white paper rather than by the outlines used in the prior lesson. Keeping these slivers from disappearing requires some care on your part as you do the hatching.

Figure 11-9 shows how to begin, with the eye and beak and with the black markings on the face and head. These black markings will require three or more layers of crosshatching. Figure 11-10 at A shows the start of the first layer of hatching on the head, back, and shoulders. Figure 11-10 at B shows the crosshatching that gives these areas the proper tone to represent the blue color of the jay. The black wing bars are put in as you see in figure 11-11 at A, and then the long wing primaries are carefully put in as at B to keep the slivers of white paper from disappearing.

Complete the wings on your drawing as shown in figure 11-12. Crosshatch over the long outer primary feathers by carrying the crosshatching right over the slivers of white paper on these feathers, as at A. Then finish the other blue wing feathers with hatching. Don't

inadvertently hatch over the white tips on some of the feathers, however, or you will have to restore the white with white gouache after the drawing is complete. Do the tail by putting in the black bars (fig. 11-13 at A), and then hatching over the tail feathers one at a time as at B.

Refer to figure 11-8 to complete the branch on your drawing.

Figure 11-9

Complete the eye, the beak, and the black markings on the head.

Figure 11-10

(A) Hatch the dark blue parts of the head, neck, and shoulders. (B) Crosshatch over these areas.

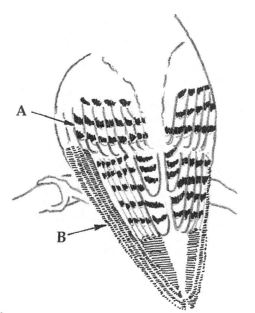

Figure 11-11

(A) Hatch the dark bars on the wings. (B) Hatch the long primary feathers on each wing, but leave narrow slivers of white paper to indicate feather separation.

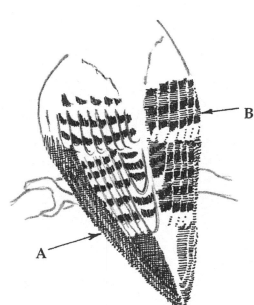

Figure 11-12

(A) Crosshatch over the long primary feathers. (B) Hatch the lighter blue feathers on the wings. Be sure to leave the white wing tips untouched.

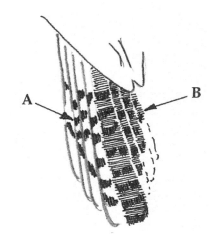

Figure 11-13

(A) Do the black bars on the tail. (B) Hatch each tail feather, one at a time. Leave the outer tips white.

97

Ink Stipple Drawing of the Blue Jay

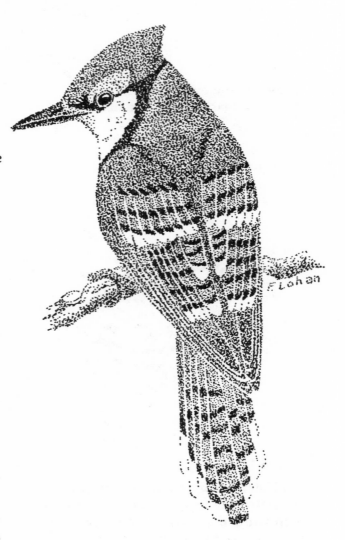

Materials

Fine-point pen (I used my 3×0 technical pen); seventy-pound smooth or vellum-finish paper.

Procedure

Of all the pen techniques, stipple (the application of dots of ink to create various tones) allows the most control of tones. It requires much more time to complete a drawing with this technique, but the results are worth it. Figure 11-14 shows the completed fine-point pen ink stipple drawing of the blue jay. Use it as a guide as you follow the step-by-step instructions.

Start your drawing as shown in figure 11-15 by doing the eye, beak, and dark markings on the face and head. Then begin to add the general tone of the head, neck, and shoulders. Figure 11-16 shows the final tone of the upper blue parts of the bird. The black bars on the wings come next (fig. 11-17 at A), and then the primary feathers (B). When you do the primary feathers, be sure to leave the sliver of white paper to suggest the separation between the

Figure 11-14

The completed fine-point pen ink stipple drawing of the blue jay. Use this to guide your drawing as you follow the instructions.

feathers (fig. 11-18 at A). The same care is needed when you stipple, as at B, the other feathers of the wings—leave the white separation between feathers. Be sure to leave the white tips on some of the feathers as at C.

Finish the tail as you see in figure 11-19. Do the black markings as at A, and then the overall stipple of the blue tone as at B. Leave the white separations here also.

Use Figure 11-14, the finished stipple drawing, to guide your work on the tree branch.

Figure 11-15

Start with the eye and beak.
Then do the black parts
of the face and head
before you start to do the
overall tone of the head and back.

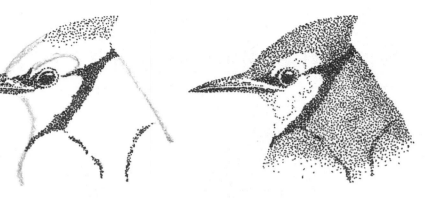

Figure 11-16

Complete the smooth tone of
the head, back, and shoulders.

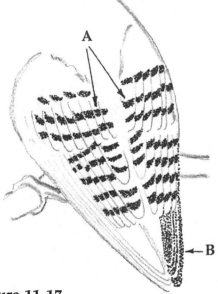

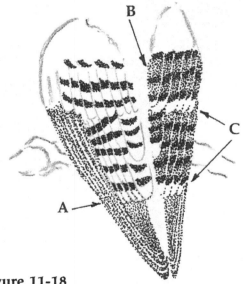

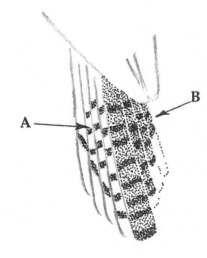

Figure 11-17

(A) Put in the black markings on the
wings. Leave a small sliver of white
paper between each feather to help
define individual feathers. (B) Do the
wing primary feathers, leaving a small
sliver of white to define each feather.

Figure 11-18

(A) Complete the wing primary
feathers, leaving the white sliver
between each one. (B) Complete each of
the wing feathers, one at a time, leaving
the little white slivers. (C) Be sure to
leave the white tips on some of the
wing feathers.

Figure 11-19

(A) Put in the dark markings on the
tail. (B) Stipple the blue parts of the
tail feathers leaving a little white to
show the feather separation.

LESSON 43
Quick Tone Studies of the Blue Jay with Coarse Pens

Materials

Medium or coarse pen (I used my artist's fountain pen), ordinary ballpoint pen, fine-point pen (I used my 3×0 technical pen); seventy-pound smooth paper.

Procedure

Prepare three working pencil outlines from figure 11-1. On the first, do a stipple drawing as shown in figure 11-20, using a coarse pen. You will find two major differences between this stipple drawing and that of Lesson 42: it will require a lot less time to do this one, and you will not be able to control the tone development as well with the coarse pen. You will quickly realize that you cannot create detail as fine at this scale. Compare this study with the previous one (fig. 11-14), which was made with a fine-point pen.

On the second pencil outline, do the drawing as shown in figure 11-21 with an ordinary ballpoint pen, using a scribble stroke. This also is a coarser point and will prevent much detail development, but you will be able to complete the drawing rapidly.

Figure 11-20

An ink stipple version of the blue jay done with a coarse pen.

Third, do the scribble-stroke drawing using your fine-point pen as shown in figure 11-22. You will be able to develop a little more detail because of the fine point, and the drawing will take a little longer to do.

Figure 11-21

A quick tone study done with a ballpoint pen and a vertical scribble stroke.

Figure 11-22

A quick tone study done with a very fine-point pen and a scribble stroke.

12 Meadowlark

The meadowlark is found in fields throughout the United States, Mexico, and southern Canada. The distinctive black V on its bright yellow breast makes this bird easy to identify. The meadowlark has a highly patterned back and wings that can appear quite complex when you first sit down to draw the bird. Lessons 44 through 46 deal with creating the illusion of this pattern with both the pen and the pencil. This general approach to developing such a pattern will apply to making drawings of other birds that also have complex plumage features.

Figure 12-1 is the working drawing of the meadowlark. Copy it on your working paper for each of the lessons, or trace it and transfer it to your paper following the instructions in Chapter 3, Lesson 1: Tracing and Transferring an Outline.

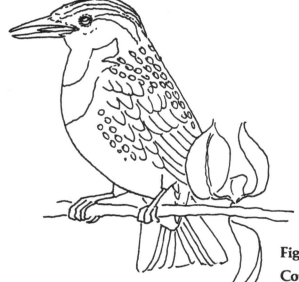

Figure 12-1

Copy or trace and transfer this working drawing of the meadowlark, and follow the step-by-step instructions to complete your drawing.

LESSON 44
Pencil Drawing on Gray Paper with Gouache Highlights

Materials

Sharp 3B or HB pencils, broad-point HB pencil; gray or other toned paper (I used gray linen-finish paper); white gouache paint; number 5 pointed watercolor brush.

Procedure

The completed drawing is shown in figure 12-2. Refer to this figure as you follow the instructions for your drawing.

Start with the eye and beak, using your sharp HB pencil, and then add the black markings on the bird's head with your sharp 3B pencil. These steps are shown in figure 12-3.

Next, using your sharp 3B pencil, put the black V on the breast and add the black markings on the sides, back, and shoulders (fig. 12-4). Finish the breast and back on your drawing as you see in figure 12-5, using the broad-point HB pencil to tone the back, right over the black markings, and to indicate the yellow throat and breast.

Figure 12-6 shows you how the lower

Figure 12-2

The completed pencil drawing of the meadowlark on gray paper with white gouache highlights. Use this figure as a reference as you complete your drawing.

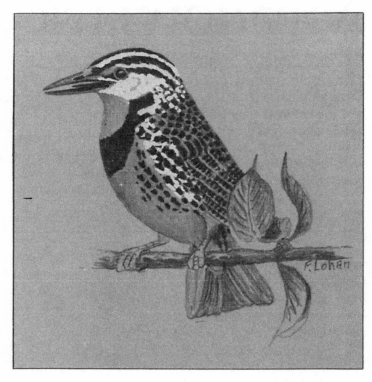

back and the lower wing feathers are patterned by drawing what look like little combs with your sharp 3B pencil. Go over the combs with your broad-point HB pencil as shown in figure 12-7.

The underpart of this bird's tail carries some of the patterning dots. Put them in as you see in figure 12-8, and

then finish the bird by toning over the tail carefully with your sharp HB pencil (fig. 12-9).

Complete the branch and leaves with your sharp 3B pencil using figure 12-2 as a guide. Then, using this same figure, paint in the white areas with the brush and gouache.

Figure 12-3

Complete the eye and beak and the black markings on the head with your sharp HB and 3B pencils.

Figure 12-4

Add the dark chest and back markings with your sharp 3B pencil.

Figure 12-5

Use your broad-point HB pencil to indicate the yellow throat and breast as well as to tone the back of the bird.

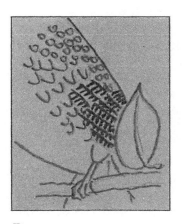

Figure 12-6

Your sharp 3B pencil puts in the combs on each wing feather.

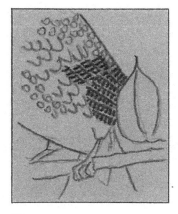

Figure 12-7

Go over each comb with your broad-point HB pencil.

Figure 12-8

Carry some of the black spots down toward the tail feathers.

Figure 12-9

Carefully shade the tail with your sharp HB pencil.

Pen-and-Ink Drawing of the Meadowlark

Materials

Sharp pen point (I used my 3×0 technical pen); seventy-pound smooth or vellum-finish paper.

Procedure

My completed pen-and-ink drawing of the meadowlark is shown in figure 12-10. Refer to it as you follow the instructions to complete your drawing of this subject.

Figure 12-11 shows how to crosshatch the eye, bill, and black stripes on the head. In crosshatching the black V on the bird's breast (fig. 12-12), I used three layers of crosshatch, shown at 1, 2, and 3. Use the pencil plumage marks as guides to hatch in the little Vs and circles on the wings and body (fig. 12-12). Next, crosshatch over the hatch marks to make them look like those in figure 12-13. The lower wing markings are somewhat like little combs, as you can see in figure 12-14.

Complete the bird's body by adding some coarse (widely spaced) hatch marks to darken the overall tone of the back and part of the wings, and to

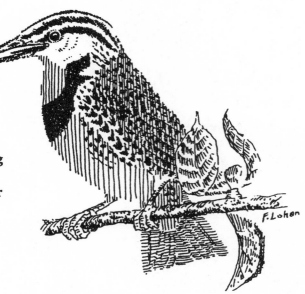

Figure 12-10

Use this completed pen-and-ink drawing of the meadowlark as a guide as you follow the instructions to complete your drawing.

indicate the yellow tone of the bird's throat, breast, and undersides (fig. 12-15).

Complete the tail as you see in figures 12-16 and 12-17, and then ink in the branch and leaves, using figure 12-10 as a reference.

Figure 12-11

Crosshatch the bill, eye, and stripes on the head.

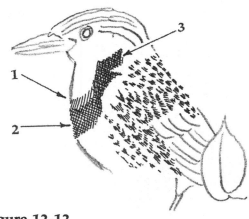

Figure 12-12

Crosshatch the black area on the breast, and then add hatch marks to develop the body and wing pattern of spots.

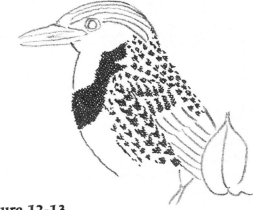

Figure 12-13

Crosshatch the spots.

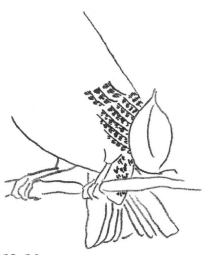

Figure 12-14

Add comb marks to the lower wing feathers.

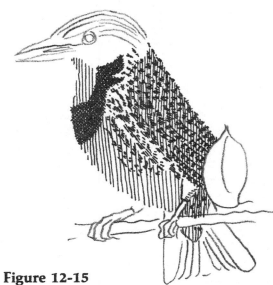

Figure 12-15

Lightly hatch over the back, breast, wing, and throat.

Figure 12-16

Add the tail details.

Figure 12-17

Hatch each tail feather, one at a time.

105

LESSON 46
Pencil Drawing on Tracing Vellum and an Ink Wash Drawing

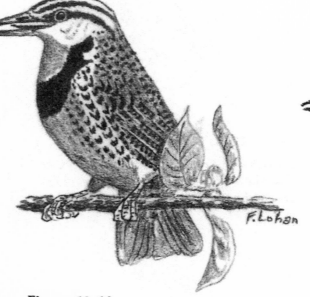

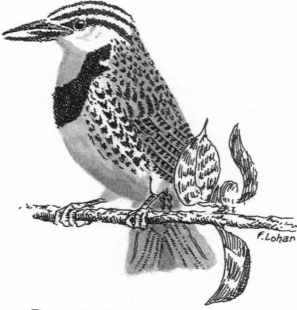

Materials

Sharp 3B and HB pencils, broad-point HB pencil; tracing vellum (a transparent high-grade tracing paper); fine-point pen (I used my 3×0 technical pen); ink wash tone 2 (one drop of ink in one teaspoon of water); seventy-pound smooth or vellum-finish paper.

Procedure

I did the pencil drawing in figure 12-18 directly on tracing vellum, a very good grade of tracing paper that is used in engineering offices for permanent file drawings. I placed it over figure 12-1 and followed the lines on the image that showed through this almost transparent paper. This procedure can save you considerable time because you do not have to draw or trace and transfer an outline of the image that you want to draw. Tracing vellum drawings perhaps look best when the translucent paper is backed up by a sheet of white paper. Tracing vellum is also good to use if you want to experiment with something before you risk making your final drawing.

Figure 12-18

Pencil drawing on tracing vellum. The vellum was placed on top of figure 12-1, and the drawing was done directly with no need to trace and transfer the outline because it was visible through the vellum.

Figure 12-19 shows you what the pen drawing looks like if ink wash (instead of ink hatching) is used to indicate the yellow breast and throat and to tone the bird's back. Compare this figure with figure 12-10.

Figure 12-19

Pen-and-ink and ink wash drawing of the meadowlark. Ink wash tone 2 (one drop of ink in one teaspoon of water) was used. Compare this treatment of the tones on the back, breast, and throat with that in figure 12-10, where the toning was done with coarse hatching.

106

13 Sandpipers

There are many different kinds of sandpipers, and almost all of them are characterized by highly patterned plumage. This chapter, devoted to drawing sandpipers, will reinforce the steps you should take in drawing something that is complex in appearance. By breaking the subject down into small areas and analyzing the predominant pattern for each area, the drawing will become quite easy as you are considering only one little part of the problem at a time.

Figure 13-1 is the working drawing of a willet, one of the larger sandpipers in North America. This is the subject for Lessons 47 and 48, the first done in pen and ink, the second in pencil. Copy this figure, or trace and transfer it using the instructions from Chapter 3, Lesson 1: Tracing and Transferring an Outline.

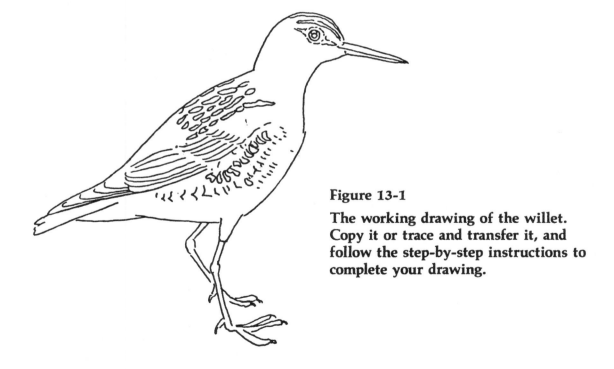

Figure 13-1

The working drawing of the willet. Copy it or trace and transfer it, and follow the step-by-step instructions to complete your drawing.

Pen-and-Ink Drawing of the Willet

Materials

Fine-point pen (I used my 3×0 technical pen); seventy-pound smooth or vellum-finish paper.

Procedure

Figure 13-2, showing the completed fine pen-and-ink drawing of the willet, should be used as a reference as you follow the instructions to do your drawing.

At a glance, the patterned parts of this bird look extremely complex. The key to successfully drawing a reasonable likeness is to study one portion of the subject to determine just what the major patterns look like. Put them in place on your drawing, fill in the less pronounced markings, and only then consider the next portion. The bird's head is treated this way in figure 13-3. Your first considerations are the eye and beak, and then the major dark stripes on the top of the head (fig. 13-3A). Next, add some of the most predominant stripes (fig. 13-3B), and finally, create the more delicate features with dots (fig. 13-3C).

The back is treated in the same way.

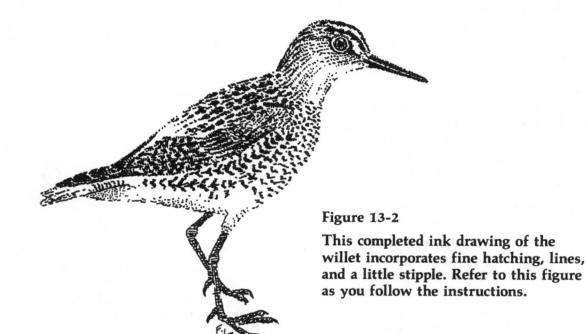

Figure 13-2

This completed ink drawing of the willet incorporates fine hatching, lines, and a little stipple. Refer to this figure as you follow the instructions.

Figure 13-4A shows how to do the major dark markings, and 13-4B shows how to add the finer detail with dots and very short hatching.

Draw in the upper wing feather markings as I show in figure 13-5A, and complete this area with the darker markings (fig. 13-5B). The lower wing feathers are treated similarly, as you see

in figures 13-6A and 13-6B.

Suggest the interesting pattern of markings on the bird's side as shown in Figure 13-7—first do the major markings (fig. 13-7A), and then the remainder (fig. 13-7B). Complete the tail, the slight shading under the body, and the legs, using figure 13-2 as a reference.

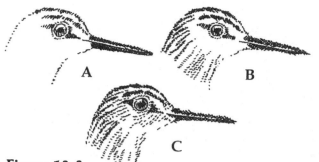

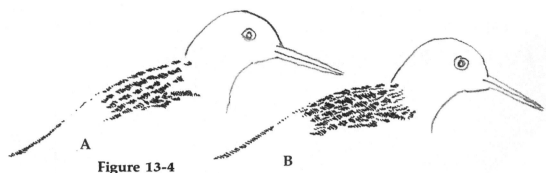

Figure 13-3

(A) Complete the eye, beak, and marks on the head. (B) Add the darker head markings. (C) Use dots to add the finer details.

Figure 13-4

(A) Add the darker markings to the bird's back. (B) Fill in with the finer markings.

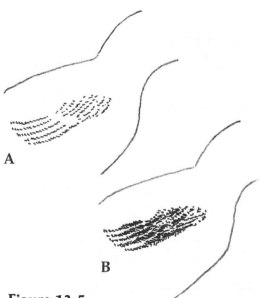

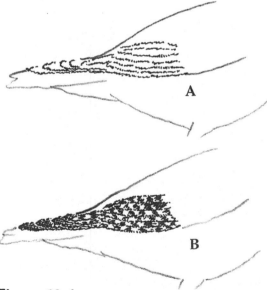

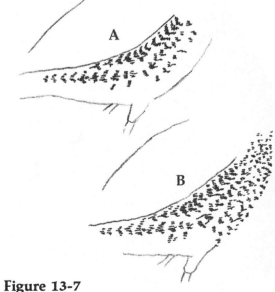

Figure 13-5

(A) Outline the upper wing feathers with short hatch marks. (B) Put the darker features in place with hatching and dots.

Figure 13-6

(A) Outline the lower wing feathers with short hatch marks. (B) Put the darker details in place.

Figure 13-7

(A) Hatch the more prominent dark Vs and bars on the bird's side. (B) Fill in the finer details with short hatch marks and dots.

LESSON 48
Pencil Drawing of the Willet

Materials

A sharp 3B or 4B pencil (I used only a sharp 4B); kneaded eraser; seventy-pound vellum-finish paper.

Procedure

The completed pencil drawing of the willet is shown in figure 13-8. The 4B pencil with its soft lead requires frequent sharpening to keep its point and does not allow quite the same control of tones that you have if you use an HB along with it. It will be worth your while to try this study with just the one pencil, however. Then try it with a harder one in conjunction with the softer lead to experience the differences in tone control for yourself. I used the kneaded eraser on the cheek area, breast area, under the tail, and on the tail itself. Then I touched up the drawing a little with the 4B pencil before I was satisfied with the results.

Figure 13-9 shows how I built up the head, working from the more prominent dark markings to the less pronounced ones, finally adding a little tone with

F.Lohan

Figure 13-8

The completed pencil drawing of the willet. Only a sharp 4B pencil and a kneaded eraser were used. Refer to this figure as you follow the instructions to complete your drawing.

the 4B pencil. Figure 13-9C shows this tone before I touched the area with my kneaded eraser.

The back is done as shown in figure 13-10; the upper wing feathers as shown in figure 13-11; and the lower wing feathers as shown in figure 13-12. You can see how simple the drawing becomes when you consider a complex subject part by part.

The sides of the willet have very interesting dark markings, some

resembling arrowheads. Figure 13-13 shows how to build up the overall representation a bit at a time. Here, too, the toning is shown as it looks before the kneaded eraser is touched to the area.

Complete the tail, undertail, and feet on your drawing by referring to the completed pencil drawing shown in figure 13-8. Remember to use your kneaded eraser on the rear shaded areas and the tail.

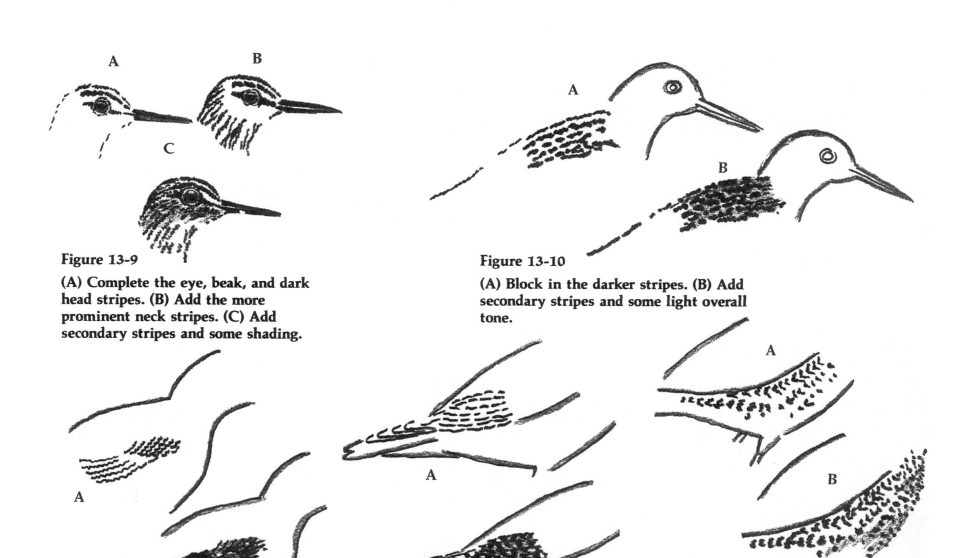

Figure 13-9

(A) Complete the eye, beak, and dark head stripes. (B) Add the more prominent neck stripes. (C) Add secondary stripes and some shading.

Figure 13-10

(A) Block in the darker stripes. (B) Add secondary stripes and some light overall tone.

Figure 13-11

(A) Mark in the upper wing feathers. (B) Put in the darks and some light overall tone.

Figure 13-12

(A) Mark in the lower wing feathers. (B) Add the dark bars, and then lightly tone over this area.

Figure 13-13

(A) Put in the more prominent markings on the bird's side. (B) Add secondary dots to fill in the pattern and lightly tone over the area along the outline.

111

LESSON 49
Stipple Drawing of the Sanderling

Materials
Fine-point pen (I used my 3×0 technical pen); seventy-pound smooth or vellum-finish paper.

Procedure
This study is about half the size of the previous two willet drawings and therefore a little more abstraction of the patterns is required—there simply is no room to draw the detailed features. Figure 13-14 is the working drawing and should be copied or traced and transferred according to the instructions in Chapter 3, Lesson 1: Tracing and Transferring an Outline. This working drawing simply locates some of the major dark plumage markings which, when done with the pen, will guide your placement of the less-prominent markings.

The first steps in doing a pen stipple drawing of the sanderling in his winter plumage (very light colored) are shown in figure 13-15. Complete the eye, beak, head markings, and major wing markings as indicated on the working drawing. Then dot in the outline so you

Figure 13-14

This is the working drawing for the sanderling. Copy it or trace and transfer it, and follow the instructions to complete your drawing.

can erase all the pencil guidelines.

The final steps, shown in figure 13-16, include stippling in the remainder of the plumage markings (basically, they are stripes with some dots placed between them when they begin to look too much like zebra markings). Stipple the legs, and then shade the lower parts of the body and the shadow on the sand. Be careful not to put too many dots on your drawing because you don't want the stripes to run together or the shaded underparts to become too dark.

Figure 13-15

First stipple the eye, beak, and major dark markings.

Figure 13-16

Next, stipple in the secondary markings on the body, do the legs, and add the shadow on the sand. This is the completed ink stipple drawing of the sanderling.

LESSON 50
Pencil Drawings of the Sanderling

Materials

Figure 13-18: very sharp 4B and HB pencils; seventy-pound vellum-finish paper; kneaded eraser. Figure 13-19: very sharp 2H and 4H pencils; tracing vellum; kneaded eraser.

Procedure

This lesson includes two pencil drawings of the sanderling. The 4B and HB pencils used for figure 13-18 on the seventy-pound vellum-finish paper had very sharp points that were absolutely essential in getting the fine markings at this small scale. Begin by using the sharp 4B for the eye, beak, legs, and dark markings (fig. 13-17). Do not make the outline dark—I did that in the illustration simply to have it show up in the printed book. I used my sharp (a very sharp point) HB pencil to put in the lighter stripes, body shading, and the shadow. Then I pressed my kneaded eraser to these areas to lighten them (fig. 13-18).

You will find that it is not possible to maintain a sharp point on the 4B pencil for more than a short stroke or two—

Figure 13-17

The first step for the pencil drawing is to do the eye, beak, legs, and dark markings with a very sharp 4B pencil. The upper and lower body outlines are shown only for visual reference in the illustration. Do *not* darken them on your drawing.

the lead is just too soft. The sharp HB does not retain the very sharp point for long either, so frequent resharpening will be required as you do your drawing.

The pencil drawing in figure 13-19 was done on tracing vellum, a more abrasive paper than the seventy-pound vellum-finish paper. I used a sharp 2H pencil (with a very sharp point) to do the dark markings shown in figure 13-17, and, to complete the drawing, a sharp 4H pencil for the lighter markings and the shading (fig. 13-19).

Figure 13-18

Complete the pencil drawing of the sanderling with your sharp HB pencil by putting in the secondary markings, the shading on the bird's body, and the shadow on the sand. Press your kneaded eraser to the head, neck, and back to lighten the tone in those areas.

This pencil drawing was done with very sharp 2H and 4H pencils on tracing vellum. The vellum was placed directly over figure 13-14 and the pencil work done with no transfer or copying of the outline. The 2H pencil was used for the darker features.

113

LESSON 51
Ink Stipple Drawing of the Least Sandpiper

Materials

Fine-point pen (I used my 3×0 technical pen); seventy-pound smooth or vellum-finish paper.

Procedure

The drawing of the least sandpiper, a sparrow-sized bird (fig. 13-22) is almost twice the size of that of the sanderling (in Lessons 49 and 50), so it is possible to show a little more of the feather detail when you use a fine-point instrument. Figure 13-20 shows the working drawing for this subject. Copy it, or trace and transfer it according to the instructions in Chapter 3, Lesson 1: Tracing and Transferring an Outline.

The location of some of the dark details on the wing and body is indicated by the pencil lines shown in figure 13-20. Use these pencil lines to guide you as you complete your drawing. Erase them when your ink work is dry and you no longer need them.

Figure 13-21 shows you how to proceed, using the pencil marks to do the stippling of the darker markings.

Figure 13-20

Copy this working drawing of the least sandpiper and stipple it with your finest pen point.

Figure 13-21

The pencil marks on the working drawing guide your stippling of the more prominent dark features.

When this part is done, use figure 13-22, the completed drawing, to guide your careful stippling to tone down some of the intermediate tone areas of the bird's back and outer wing tips. As

Figure 13-22

The completed pen-and-ink stipple drawing of the least sandpiper. Use this figure to guide your stippling of the tone between some of the black markings.

you do this, you may notice that some of the darker details start to disappear. Reinforce them immediately or you may lose their position in the intermediate tone you are creating.

14 Flying Osprey

As you near the end of this book, you should have had enough experience with pens and pencils to begin to do some work on your own. Because the principles for approaching the variety of drawing subjects covered so far can be fairly universally applied, I have reduced the number of step-by-step instructions in this chapter. Rely on what you have learned from the previous lessons, and concentrate on developing your ability to apply this knowledge to other subjects.

One way to get real action into your bird drawings is to portray the birds in flight. In order to do this you will have to acquire action photographs of the birds you are interested in drawing. There are many superb sources available. One is stop-motion photography that captures some very dramatic live action and postures that cannot be seen with the naked eye. Very frequently, however, such photographs have highlights that are devoid of detail as well as dark shadows in which no detail is visible. You may have to use several sources before you can see the detail that is not visible in

Figure 14-1

This is the working drawing of the first study of the flying osprey. Carefully copy it on your paper, or trace and transfer it.

the action photograph you want to draw. This was the case with my source photographs for the next subject, a flying osprey. Each of these working drawings was based on three or four different photographs.

Figure 14-1 is the working drawing for the first three studies of the osprey. Copy it on your paper for each of these studies, or trace and transfer it by following the instructions in Chapter 3, Lesson 1: Tracing and Transferring an Outline.

LESSON 52
Pen-and-Ink Study of the Flying Osprey

Materials

A fine-point pen (I used my 3×0 technical pen); seventy-pound smooth or vellum-finish paper.

Procedure

Figure 14-2 shows the completed pen-and-ink drawing of the osprey. Refer to it continually as you draw yours. The principles used in this drawing are the same as those you have applied to most of the preceding pen-and-ink drawings in this book. Indicate the dark features and areas, and then add secondary detail and crosshatching to achieve the desired dark tones.

Complete the eye, beak, and head area first, referring to figure 14-3, which shows the starting pen strokes. The darks will require at least two layers of crosshatching—more, if you do not place the lines very close to one another.

Next, work on the osprey's right wing (fig. 14-4). Be sure to leave a sliver of white paper between the wing and the head and neck part of the bird as shown at A. At the completion of your drawing you will tone this sliver down with a few strokes of the pen, but it is essential

Figure 14-2

This is the completed pen-and-ink drawing of the flying osprey. Refer to this figure as you follow the instructions to complete your drawing.

to provide some visual separation between the two parts of the bird and give some arial perspective to the drawing. Next, put in the dark areas and markings on the wing with hatching (at B). Now crosshatch one half of the length of each primary and secondary feather as shown at C. Crosshatch over half of the feathers again (at D).

Finally, complete these feathers by crosshatching over the entire feather, one at a time, as at E. Now refer to the completed drawing, figure 14-2, to guide your crosshatching that completes this wing.

The osprey's left wing is started, as you see in figure 14-5, by blocking in all the darker areas with hatching. Again, use figure 14-2 as a reference to guide your crosshatching that completes this wing.

The tail area is completed in a similar

F. Lohan

way. Indicate the darks as you see at A in figure 14-6, and then crosshatch half of each feather as at B. Now refer to the completed drawing, figure 14-2, to guide your final crosshatching, the completing of the feet, and the shading on the bird's lighter parts.

116

Figure 14-3

This shows the starting pen strokes around the bird's head and neck.

Figure 14-4

(A) Be sure to leave a white sliver between the bird's right wing and its neck and shoulder area. (B) Draw in all the dark features on the wing feathers. (C) Crosshatch the length of one half of each wing feather. (D) Crosshatch again over the same area. (E) Crosshatch each feather completely with slightly wider spaced strokes.

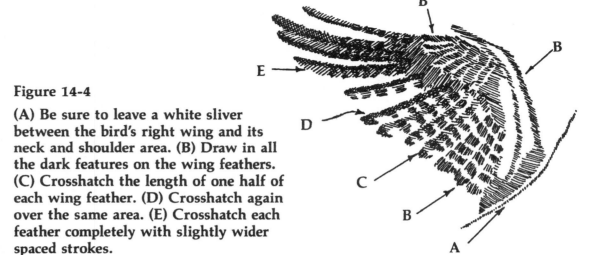

Figure 14-5

Block in all the dark patterns on the wing before you start your crosshatching.

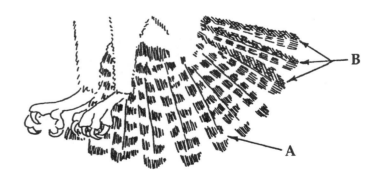

Figure 14-6

(A) Put in all the dark bars on the tail feathers. (B) Crosshatch the full length of one half of each tail feather. Check figure 14-2 to see which half to crosshatch on the different feathers.

117

Pencil Drawing on Tracing Vellum of the Flying Osprey

Materials
Sharp 2H and 4H pencils; tracing vellum; kneaded eraser.

Procedure
I did the drawing in figure 14-7 by placing tracing vellum over figure 14-1 and using only sharp 2H and 4H pencils to reproduce the image that I could see through the tracing paper. I used these harder pencils because the tracing vellum is quite abrasive and picks up more graphite than softer drawing paper does. The 2H pencil was used for all the darks, and the 4H completed the lighter tones.

Try this study on tracing vellum the same way I did it, and see how quickly you can produce a nicely done drawing.

Figure 14-7

This pencil drawing of the flying osprey was done on tracing vellum placed directly over figure 14-1. I used only sharp 2H and 4H pencils.

LESSON 54

Another Pencil Drawing of the Flying Osprey

Materials
Sharp 4B, B, and HB pencils, and
broad-point HB pencil; kneaded eraser;
seventy-pound vellum-finish paper.

Procedure
The working drawing of the osprey in a
different flying pose is shown in figure
14-8. This study, somewhat smaller
than the previous one, is also completed
both in ink and in pencil, in this and
the following lesson.

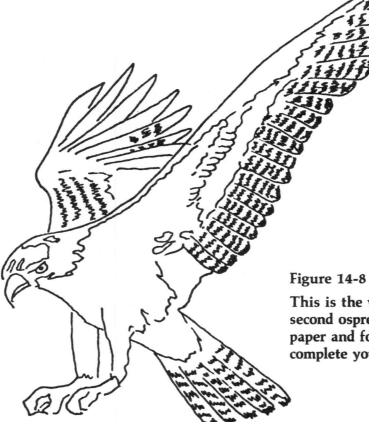

Figure 14-8

This is the working drawing of the
second osprey subject. Copy it on your
paper and follow the instructions to
complete your drawing.

You see the completed pencil drawing in Figure 14-9. This study, smaller than the last one, requires quite sharp pencils so that detail is not lost. Figure 14-10 shows you how to lay in the darkest areas with your 4B pencil. Be sure to leave the little white sliver between the wing and the bird's back. Use your B pencil to do the remaining darks so that the very dark features still show through (fig. 14-11).

The osprey's left wing is completed in a similar manner. Put the darkest darks in with your 4B pencil as at A in figure 14-12, and then use your B pencil to tone the wing as at B. Finally, use your broad-point HB pencil to tone the lightest areas as at C.

Your 4B pencil is used to block in the darks on the bird's head (fig. 14-13), and the head is completed as in figure 14-14. Your broad-point HB pencil point does the toning in the very lightest areas.

The feet are done with a sharp HB and a broad-point HB, as shown in figure 14-15.

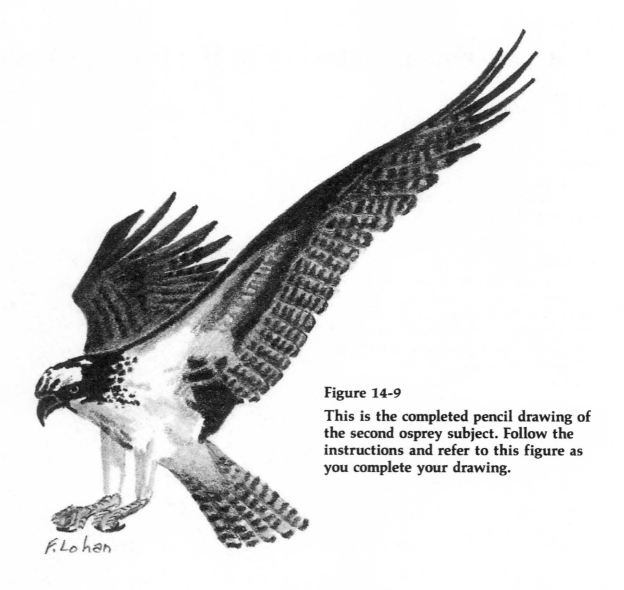

Figure 14-9

This is the completed pencil drawing of the second osprey subject. Follow the instructions and refer to this figure as you complete your drawing.

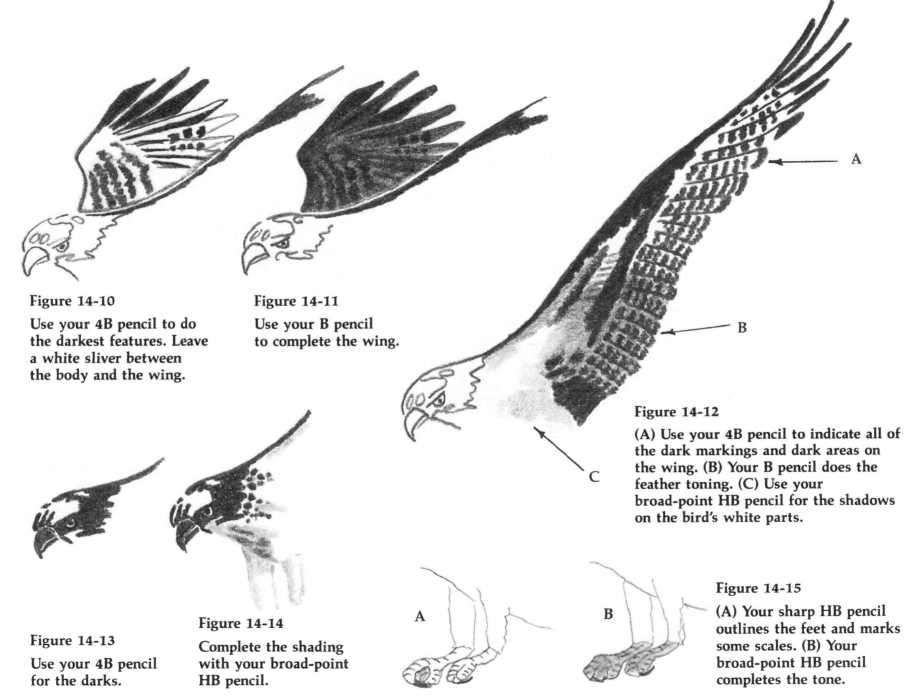

Figure 14-10

Use your 4B pencil to do the darkest features. Leave a white sliver between the body and the wing.

Figure 14-11

Use your B pencil to complete the wing.

Figure 14-12

(A) Use your 4B pencil to indicate all of the dark markings and dark areas on the wing. (B) Your B pencil does the feather toning. (C) Use your broad-point HB pencil for the shadows on the bird's white parts.

Figure 14-13

Use your 4B pencil for the darks.

Figure 14-14

Complete the shading with your broad-point HB pencil.

Figure 14-15

(A) Your sharp HB pencil outlines the feet and marks some scales. (B) Your broad-point HB pencil completes the tone.

121

Another Pen-and-Ink Study of the Flying Osprey

Materials

A fine-point pen (I used my 3×0 technical pen); seventy-pound smooth or vellum-finish paper.

Procedure

The working drawing for this study is shown in figure 14-8. Copy it on your paper. Except for the pose and the size of the drawing, this study is very much like that of Lesson 52. The same general principles apply here—block in the darks, and then do the lesser detail and the shading and toning that complete the drawing (fig. 14-16). This will be a good exercise for you to try with no specific step-by-step instructions. If you feel lost, refer to the instructions for Lesson 52 and adapt them to this study.

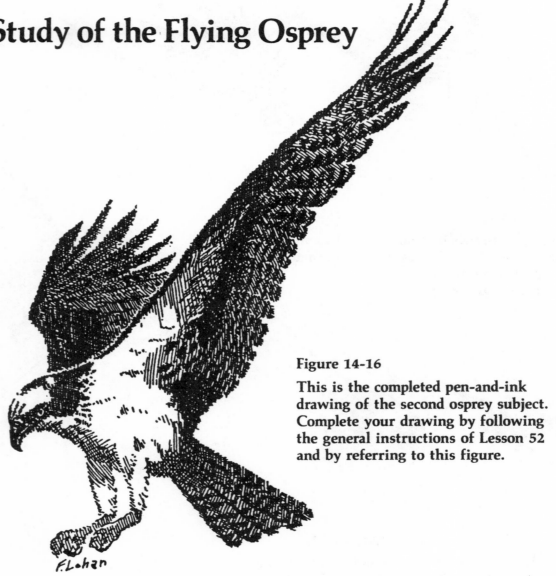

Figure 14-16

This is the completed pen-and-ink drawing of the second osprey subject. Complete your drawing by following the general instructions of Lesson 52 and by referring to this figure.

15
Other Studies

In previous chapters you have learned techniques for using pencil, pen, and ink wash to draw quite a variety of bird subjects. Now it is time for you to apply what you have learned in drawing a few final subjects with no step-by-step suggestions from me.

Your next step will be to find your own photographic references and, based on your own observations from life, to draw forms and features with the black-and-white media we have been using. Just remember that, by and large, you are simply *suggesting* features—you cannot, at the scale we used in this book, draw every feather that a photograph may show on a bird. You must simplify what you see and use only the most significant features. This is the intellectual challenge of drawing anything, be it a bird, an animal, or a landscape.

LESSON 56
Small Pencil Study of the Osprey

Materials
Very sharp HB and 2H pencils; tracing vellum.

This pencil study, figure 15-2, was done on tracing vellum placed directly over figure 15-1. The pencils were kept very sharp. This is a quick study and, because of its small size, required a great deal of simplification from the photograph I used for reference.

Figure 15-1

This is the working drawing for a small study of a flying osprey.

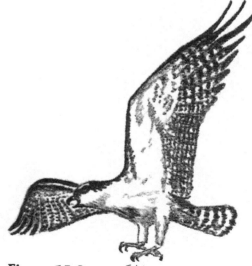

Figure 15-2

The completed pencil study of the osprey. Very sharp pencil points are needed to suggest details in a study this small.

Pencil Drawing of the Screech Owl

Materials
Sharp 4B and B pencils, broad-point HB pencil; kneaded eraser; seventy-pound vellum-finish paper.

Figure 15-3 shows the working drawing for the screech owl study. I simplified the very complicated pattern on this bird's feathers as you see in figure 15-4. I used the sharp 4B pencil to put in the major dark markings as shown in figure 15-4A and 15-4B. I then toned the area with a broad-point HB pencil (fig. 15-4C), and finally added the secondary wiggly lines (fig. 15-4D). The final result is shown in figure 15-5.

Figure 15-3

The working drawing for the screech owl study.

Figure 15-4

Proceed with the indications of the darker features first, and then do the toning and add the secondary feather features.

Figure 15-5

The completed pencil drawing of the screech owl. Pencils used were 4B, B, and broad-point HB.

Pencil and Pen Studies of the American Kestrel (Sparrow Hawk)

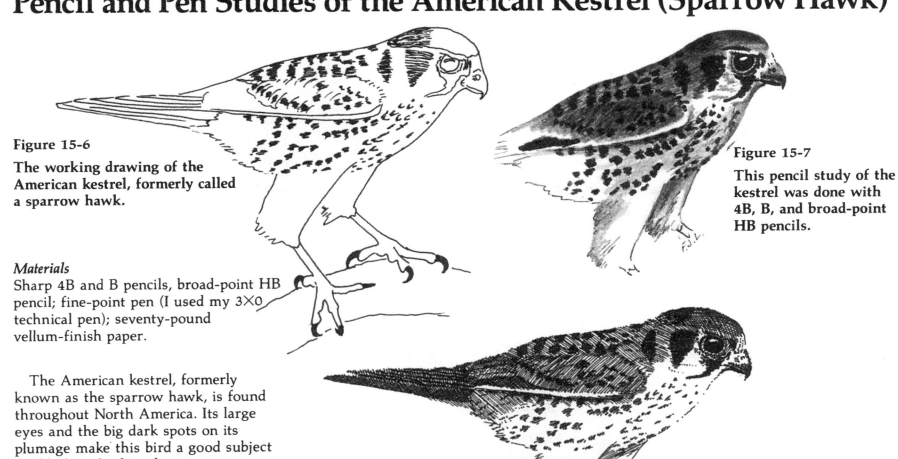

Figure 15-6

The working drawing of the American kestrel, formerly called a sparrow hawk.

Figure 15-7

This pencil study of the kestrel was done with 4B, B, and broad-point HB pencils.

Materials

Sharp 4B and B pencils, broad-point HB pencil; fine-point pen (I used my 3×0 technical pen); seventy-pound vellum-finish paper.

The American kestrel, formerly known as the sparrow hawk, is found throughout North America. Its large eyes and the big dark spots on its plumage make this bird a good subject for black-and-white drawing.

The working drawing is seen in figure 15-6. The completed pencil study, done with 4B, B, and HB pencils, is seen in figure 15-7. The ink study in figure 15-8 was done on vellum-finish paper with my 3×0 technical pen.

Figure 15-8

The completed pen-and-ink study of the American kestrel.

LESSON 59
Pen-and-Ink Drawing of the Goshawk

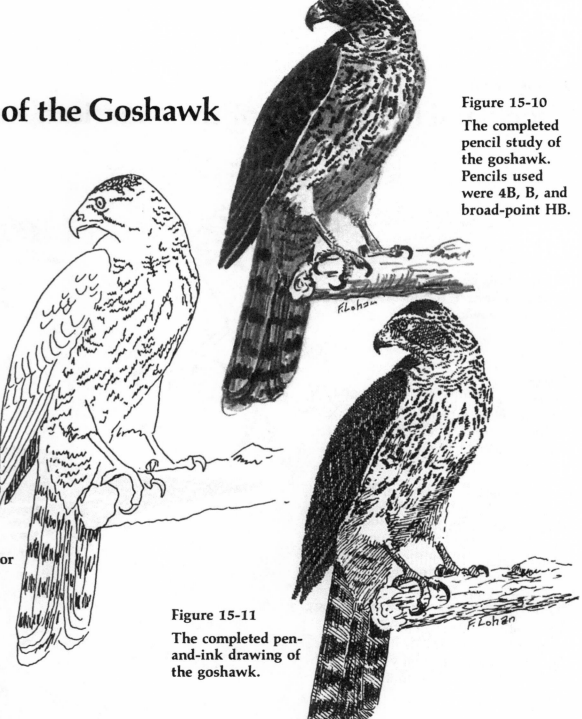

Figure 15-10

The completed pencil study of the goshawk. Pencils used were 4B, B, and broad-point HB.

Materials
Fine-point pen (I used my 3×0 technical pen); seventy-pound vellum-finish paper; 4B, B, and broad-point HB pencils.

Figure 15-9 is the working drawing of the goshawk. The pencil drawing, figure 15-10, was done with sharp 4B and B pencils. A broad-point HB pencil was used for the lighter shading, which I put in over the darker details.

A pen-and-ink study is shown in figure 15-11. The crosshatching on the wings, cheeks, tail, and underparts was done after the dark features were all in place.

Figure 15-9

The working drawing for the goshawk studies.

Figure 15-11

The completed pen-and-ink drawing of the goshawk.

16
Making Your Own Notepaper

Pen-and-ink drawings, which can be reproduced inexpensively, are perfect for making your own notepaper. You can very easily make the notepaper layout yourself with just an 8½" by 11" piece of paper, a pair of scissors, a glue stick, and one of your drawings, either drawn to the proper size or reduced from the original size by a copy machine.

A standard-size notepaper layout is based on a folded 8½" by 11" sheet of paper, illustrated in figures 16-1 through 16-3. A standard-size envelope is 6½" by 3⅝"; the size and fold to fit this envelope is shown in figure 16-4. This same size paper, 6⅜" by 7", can be printed as you see in figure 16-5. You can easily experiment, run your layouts off on a copy machine, cut them to size, and see how they look before you consider having them printed at a local print shop.

Figure 16-1

An 8½" by 11" sheet of paper folded twice will fit a standard envelope.

Figure 16-2

The first fold of the 8½" by 11" sheet of paper.

Figure 16-3

The second fold of the 8½" by 11" sheet.

Figure 16-4

A 6⅜" by 7" sheet of paper folded once will fit into a small standard envelope.

Figure 16-5

Another notepaper layout for a small envelope.

127

Reducing Ink Drawings

Line drawings in ink reduce very well as long as the line work is somewhat open—that is, the lines must have some white between them. As you reduce a drawing, the lines tend to run together and produce solid black areas. Figures 16-6 through 16-8 first show an ink line drawing full size as drawn, reduced to 70 percent of original size, and reduced to 50 percent of original size. At the 50 percent point some of the lines begin to run together, as you see in figure 16-8.

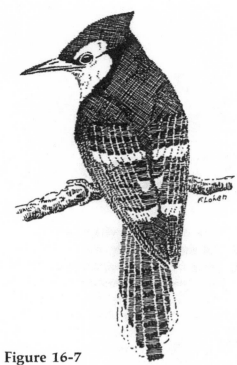

Figure 16-7

A reduction to 70 percent of original size.

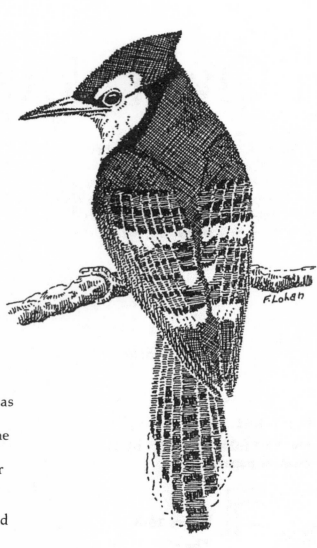

Figure 16-6

A full-size line drawing, as drawn with a 3×0 technical pen.

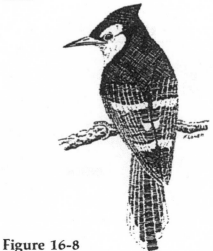

Figure 16-8

A reduction to 50 percent of original size.

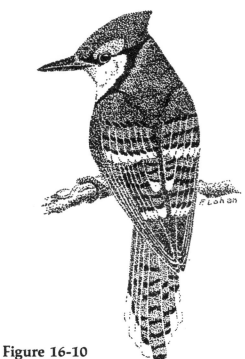

Figure 16-10

A reduction to 70 percent of original size.

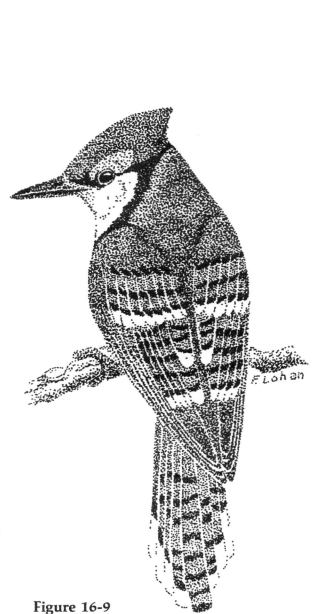

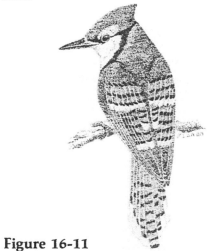

The same subject, a blue jay, is drawn with the ink stipple technique in figures 16-9 through 16-11. Stipple reduces very well and doesn't run together as much as line work does. Compare the 50 percent reduction of the stipple drawing in figure 16-11 with the line drawing of the same subject in figure 16-8.

Figure 16-9

An ink stipple drawing at the original size drawn.

Figure 16-11

A reduction to 50 percent of original size.

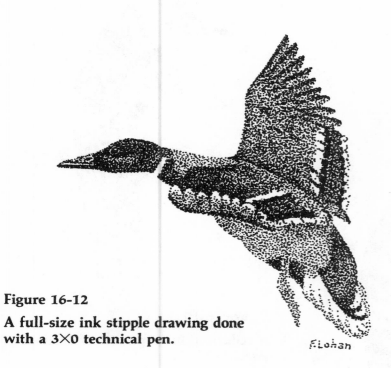

Figure 16-12

A full-size ink stipple drawing done with a 3×0 technical pen.

A final example of the ability of stipple to reduce quite well is shown in figures 16-12 through 16-14. This time, a flying mallard is shown full size as originally drawn, at 70 percent reduction, and at 50 percent reduction. In figure 16-14 you can see how well the various tones held their relationship at this reduction.

If you consider making your own notepaper, a printer can offer some helpful suggestions before you start, as well as give you some cost estimates for the printing and the envelopes.

Figure 16-13

A reduction to 70 percent of original size.

Figure 16-14

A reduction to 50 percent of original size. There is very little indication of "filling in" to solid black.

17
On Your Own

I stated in the Introduction that learning to draw is a never-ending process. I have been drawing for more than 50 years and teaching drawing for more than 16 years, yet I learned significant things as I wrote this, my sixth book. Now, having done many of the exercises in this book, you have learned some fundamentals and gained a little dexterity with the tools. You are ready to learn to draw!

No one can teach you to draw. *You* must learn all by yourself, and you will learn by doing. Art teachers and art instructors can guide you in how to use some of the techniques, and, by following their recipes and suggestions, you will be able to produce more or less credible drawings. But you must develop an ability to "see" along with a capability to create impressions on paper.* This comes only with practice.

I taught you nothing in this book; if you learned anything, it was totally because of your own interest and effort. All I did was show you several ways of handling some of the drawing tools to produce some specific effects. I hope I inspired you to try to do many of the drawings and that you have become somewhat familiar with how the tools feel and how they are used to produce various impressions on paper. Now you must look at life, along with looking at other reference materials, and begin learning how to draw those things—be they birds or whatever—that emotionally move you to *want* to draw them. I hope that I have helped you develop your interest, for only with continued interest and constant trying can you teach yourself the "how" of drawing.

Good luck!

*How to see the geometry of nature and how to draw natural things (birds, animals, flowers, and trees) more readily is the basis of my earlier book *Wildlife Sketching*, also published by Contemporary Books, Inc.

Other Books by Frank J. Lohan

Pen and Ink Techniques, Contemporary Books, Inc., Chicago, 1978, 93 pages.

A pen-and-ink sketching book for the beginner, it describes the materials required and gives ten basic step-by-step demonstrations as well as reference sketches covering a wide variety of subjects.

Pen and Ink Themes, Contemporary Books, Inc., Chicago, 1981, 106 pages.

This is a sketch-filled idea book that shows artists how to look around themselves to find sources of subject matter to sketch.

Pen and Ink Sketching Step by Step, Contemporary Books, Inc., Chicago, 1983, 130 pages, indexed.

Thirty-six step-by-step pen-and-ink demonstrations are included in this book. The subject matter covers barns, owls, raccoons, mountain lions, deer, ducks, songbirds, toads, stone lanterns, boats, and more.

Wildlife Sketching, Contemporary Books, Inc., Chicago, 1986, 240 pages, indexed.

Chapters on materials, drawing techniques, and basics of perspective introduce this book on how to sketch songbirds, trees, animals, flowers, mushrooms, water birds, reptiles, amphibians, and more. More than 600 individual drawings are included to show the artist how to draw each subject in pencil and in pen.

Countryside Sketching, Contemporary Books, Inc., Chicago, 1989, 270 pages, indexed.

Covers how to draw rocks, country walls, wood and wooden things, lakes, streams, waterfalls; Southwestern USA scenes, mountain countrysides, rural North American scenes, English countrysides, and more, with easy to follow instructions for drawing with pen or pencil.

*Available as Dover reprints. Go to www.doverpublications.com for more information.

Index

W